INTRODUCING GILBERT & GEORGE

ROBERT ROSENBLUM

with 75 illustrations, 66 in colour

Thames & Hudson

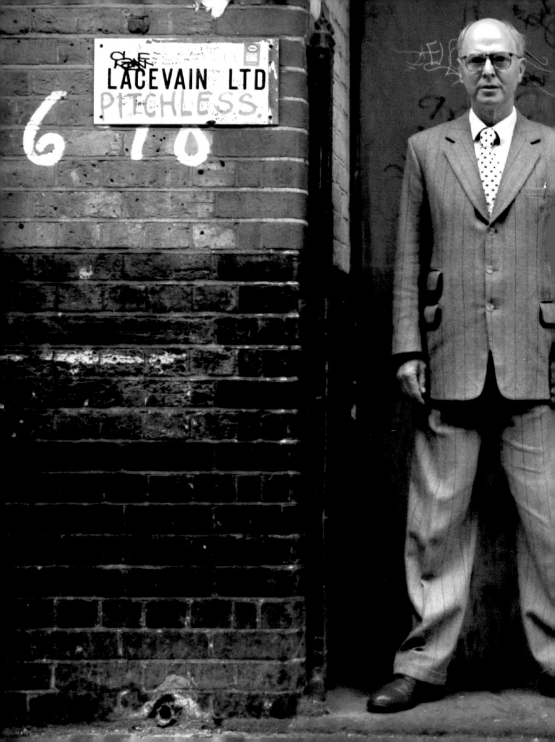

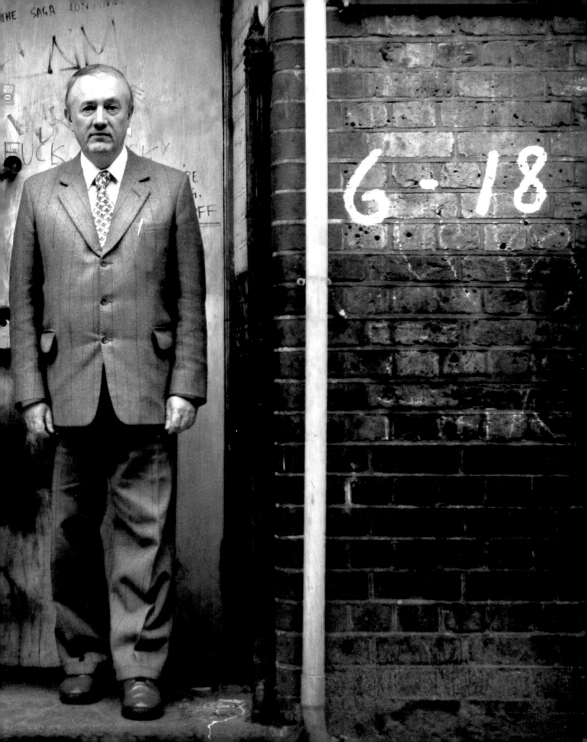

On previous pages: photograph Timothy Allen/The Independent

First published in the United Kingdom in 2004 by Thames & Hudson Ltd, 181A High Holborn, London WC1V 7QX

www.thamesandhudson.com

British Library Cataloguing-in-Publication Data
A catalogue record for this book is available from the British Library

ISBN 0-500-28485-7

Design by Herman Lelie
Typesetting by Stefania Bonelli

Printed in the UK by Beacon Press

CONTENTS

9 Couples & Fraternities

24 Radicals & Progressives

46 City & Country

81 Heaven & Hell

109 Private & Occult

148 Then & Now

167 Gilbert & George: A Chronology

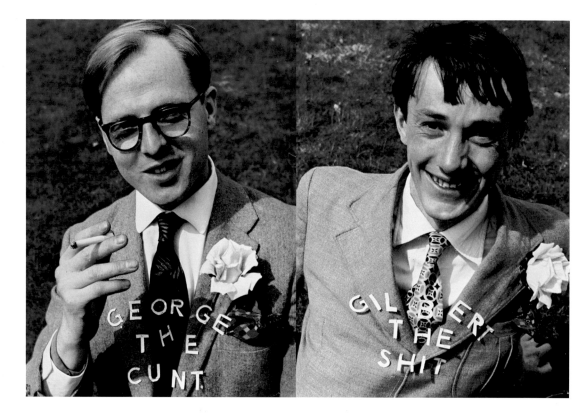

1 MAGAZINE SCULPTURE 1969

We have inside ourselves a lot of thoughts, feelings, desires, dreams, hopes, fears – many things inside. And we, as artists, have a great, burning ambitious need to tell these things and put these things out of ourselves.
1986

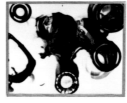

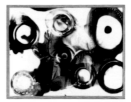

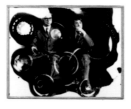
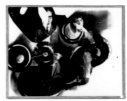

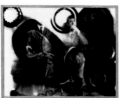
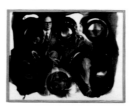
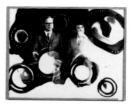
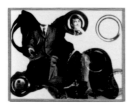
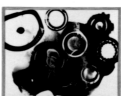

2 BOTTOMS UP 1973 | 109 x 71 cm (43 x 28 in)

COUPLES & FRATERNITIES

Of the singularity of Gilbert & George's duality in life as in art, there is little doubt. They dress alike (the ties might be of similar pattern but different colour); they seem to speak out of one mouth, despite the difference of accents (one from Devon, one from the Dolomites); their first-person singular 'I' is always the first-person plural 'we'; their signature (at times inverted as George and Gilbert) is a joint one; their lives are always those of an inseparable duet; their art, both the thinking it up and the making of it, never for a moment makes us wonder who did what; and together they own an astonishing, Georgian house and tiny yard on Fournier Street, now worthy of consideration as a national monument, in the way that Sir John Soane's house across London in Lincoln's Inn Fields is a uniquely personal fantasy. Even the now preferred punctuation for their name, Gilbert *&* George rather than Gilbert *and* George implies, with its ampersand, the kind of indissoluble liaison expected from a single firm.

Yet they are not alone in this twinning, a phenomenon mysteriously captured in a series of five painted portraits by Gerhard Richter (1975), who showed them fused in an

almost ectoplasmic union directly inspired by their own picture *Dark Shadow no. 6* (1974, fig. 10) from the previous year. Among their older and younger contemporaries there are many other examples of artist-couples who, whether united as identical twins, husband and wife, siblings, same-sex partners, or just friends who share a vision, make singular art from double authorship. In London, the list might begin with the Chapman Brothers, who, as aspiring young artists, once worked for Gilbert & George. As for those who, like Gilbert & George, work primarily within the medium of photography, there is the German married couple Bernd and Hilla Becher, the American identical twins Mike and Douglas Starn, and the French gay couple Pierre et Gilles. But the list also extends to multi-media and installation artists: the Russians Vitaly Komar and Alexander Melamid, the Swiss Peter Fischli and David Weiss, and the British Tim Noble and Sue Webster, who, in 1994, as a flyer for their show, pasted their own two heads onto a photo of Gilbert & George. As for artist duos who live a fictional lifestyle, right down to period clothing, there are the Americans David McDermott and Peter McGough, who make both paintings and photographs and have made twin photographs of Gilbert & George. Of course, there are many

famous artist couples from an earlier twentieth-century vintage – Robert and Sonia Delaunay, Hans Arp and Sophie Taeuber, Josef and Anni Albers, Gabriele Münter and Vasily Kandinsky, Diego Rivera and Frida Kahlo, Lee Krasner and Jackson Pollock – but despite the closeness of these personal relationships, their work can always be clearly differentiated, even though it may overlap at times.

In a way, Gilbert & George's unity of vision and execution strikes more familiar chords with the nineteenth century, when brotherhoods were formed by angry young artists who, with a single voice and a communal style, would rise up against the art establishment. Of these, the German Nazarenes and the British Pre-Raphaelite Brotherhood are the best known, the latter, of course, being particularly relevant to Gilbert & George. These young voices of 1848 – among them, Holman Hunt's, Dante Gabriel Rossetti's, and John Everett Millais's – wanted to protest with one mouth and to paint, so to speak, with one brush, masking their individual identities with the group's monogram signature 'PRB'. Their written manifestos, like the alternative proposals for the title of their periodical *The Germ* (these included *The Guide to Nature*, *The United Arts*, *The Chariot*, *The Wheel*), carry the evangelical, reformatory tone that Gilbert & George

have in their own proclamations. The texts in the huge charcoal-on-paper 'sculptures', as they call them, titled 'To be with Art is All We Ask …' (1970, figs 5 and 6), and continuing with 'Oh, Art, what are you? You are so strong, so powerful, so beautiful and moving', suggest a fervently fulsome resurrection of nineteenth-century art rhetoric, as do such comments as Gilbert's 'The eye is the way to the true forces. Visual is foremost a religion of thought', immediately expanded by George, who adds 'thought and feeling and dreads, hopes, fears – everything there is.'

3 THE SINGING SCULPTURE 1970 at Düsseldorf Kunsthalle

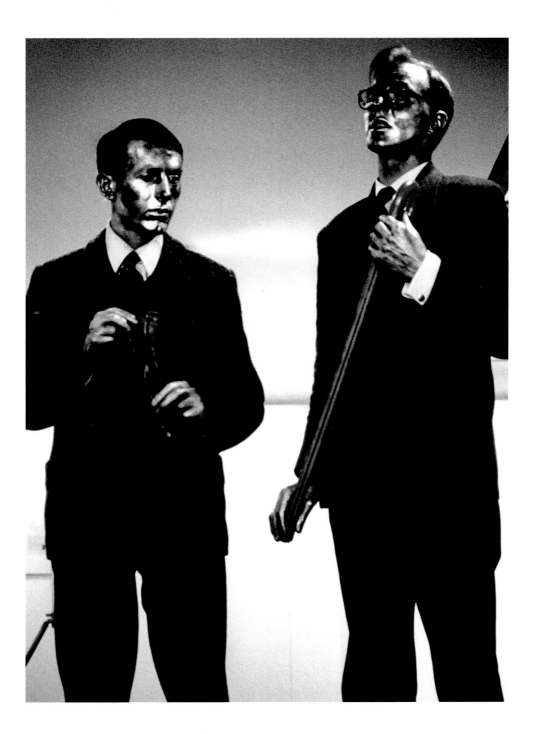

Gilbert: First we made objects of our own and showed them together, then we did one object together – one mask, a head. I would put in whatever I wanted, and then George put in whatever he wanted, and so on, and then it was finished.

George: You could say that was a collaboration. We've never collaborated in that way since.

Gilbert: In a way, that happened by mistake. Because at the end of the year we posed with our objects, holding our sculptures …

George: … and then we did the same without the sculptures.

Gilbert: We realised we didn't need the objects any more. It was just us.

George: And in our little studio in Wilkes Street in Spitalfields we played that old record *Underneath the Arches*. We did some moving to it, and we thought it would be a very good sculpture to present. And that in a way was the first real G & G piece. Because it wasn't a collaboration. We were on the table as a sculpture, a two-man sculpture.
1995

A Guide to

Singing Sculpture

by

GEORGE & GILBERT

the human sculptors

1970

'Art for All,' 12 Fournier Street, London, E.1, England
Tel. 01 247 0161

SIX F
towards a bett

Essentiall
we carve our

Together with you
as much contact for e

Humar
makes available every

It is significant
is able to sing its mess

The sculptors,
are given over to feeling

It is intended that this sculp
generous and

TS
rstanding

ture
the air.

pture presents
ng as is possible.

re
you can think of.

sculpture
words and music.

sculpture,
of the world of art.

gs to us all a more light
rt feeling.

SCULPTING WORDS

The Ritz we never sigh for, occasionally we have a drink there, *the Carlton they can keep, there's only one place that we know and that is where we sleep. Underneath the arches* is still our most important realistic abstract wording. It lives along with us as we dream our dreams away realising how few people have had thoughts on these our sculpture words for we are really working at dreaming our dreams away. *Underneath the arches on cobblestones we lay* is increasingly our position as day after day we rest on these our cobblestones. *Every night you'll find us tired out and worn* for after a day of sculpting we are sometimes a little tired. *Waiting till the day-light comes creeping heralding the dawn* of another day of light in which to find our sculpture way throughout that time. *Sleeping when its raining and waking when its fine*, its all the same to us and it doesn't matter where we are or what we are doing as long as we sculpt along our way. *Trains travelling by above* as everything goes along leaving us here. *Pavement is our pillow*, but then whats wrong with that, *no matter where we stray*, we are there with our all. *Underneath the arches we dream our dreams away.*

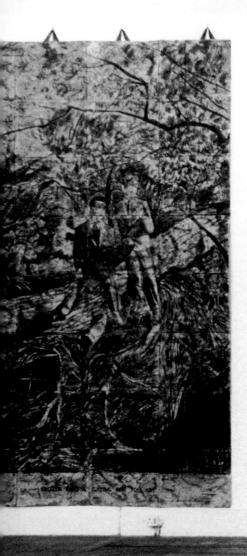

To be with Art is a

OH ART, what are you? You are so strong and powerful, so beautiful and moving. You make us walk around and around, pacing the city at all hours, in and out of our Art for All room. We really do love you and we really do hate you. Why do you have so many faces and voices? You make us thirst for you and then to run from you, escaping completely into a normal life - getting up having breakfast, going to the work-shop and being sure of putting our mind and energy into the making of a door or maybe a simple table and chair. The whole life would surely be so easeful, so drunk with the normality of work and the simple pleasures of loving and hanging around for our lifetime. Oh Art, where did you come from, who mothered such a strange being. For what kind of people are you - are for the feeble of mind are you for the poor-at-heart are for those with no soul. Are you a branch of nature's fantastic network or are you an invention of some ambitious men? Do you come from a long line of arts? For every artist is born in the usual way and we have never seen a young artist. Is to become an artist to be reborn, or is it a condition of life? Coming slowly over a person like the daybreak. It brings the art-ability to do this strange thing and shows you new possibilities for feeling and scratching at oneself and surroundings. setting standards, making you go into every scene and every contact, every touching nerve and all your senses. And Art we are driven by you at incredible speed, ignorant of the danger you are pushing and dragging us into. And yet

Art, there is only on and on good times t and wait only f table. If you o mean to us, t of tragedy en ful life of hap good times ar are able to wa held high. We a little light th to be happy a again. An Art, we cont art to you alo sure, for Art like to say to y to be your sou all the time ar about you. W When we real we meet you glimpsed you and have taste we thought w street. you w suit. white sh you looked ver about your dr dryness. You of step and th We were fascu your face, yo and your dust proached yo we needed yo a second and again. We felt same time ha

18

e ask...

GILBERT and GEORGE
1970

...ck, all roads go
...ppy for the
...e us and we work
...t bits from your
...ow much these
...g from the depths
...peir to a beauti-
...ng us where the
...is happens we
...ith our heads
...d only to see a
...ees of the forest,
...and back into
...don't forget you,
...icate our artists
...and your plea-
...would honestly
...happy we are
...hink about you
...g sentimental
...e that you are
...r and many times
...me. We have
...d almost world
...eality. One day
...n a crowded
...d in a light brown
...rious blue tie.
...t there was
...s womess and
...g alone, light
...trolled sense
...he lightness of
...olourless eyes
...air. We sup-
...and then just as
...out of sight for
...ld not find you
...lucky and at the
...eful to have

seen your reality. We now feel very fami-
liar with you, Art. We have learned from
you many of the ways of life. In our work
of drawings, sculptures, living-pieces,
photo-messages, written and spoken
pieces we are always to be seen, frozen
into a gazing for you. You will never find
us working physically or with our nerves
and yet we shall not cease to pose for you,
Art. Many times we would like to know
what you would like of us, your messages
to us are not always easily understood.
We realize that it cannot be too simple
because of your great complexity and all-
meaning. If at times we do not measure
up or fulfil your wishes you must believe
that it is not because we are unserious
but only because we are artists. We ask
always for your help, Art, for we need
much strength in this modern time, to be
only artists of a life-time. We know that
you are above the people of our artist-
world but we feel that we should tell you
of the ordinariness and struggling that
abounds and we ask you if this must be.
Is it right that artists should only be able
to work for you for only the days when
they are new, fresh and crisp. Why
can't you let them pay homage to you
for all their days, growing strong in your
company and coming to know you better.
Oh Art, please let us all relax with you.
Recently, Art, we thought to set ourselves
the task of painting a long set of narra-
tive views descriptive of our looking for
you. We like very much to look forward
to doing it and we are sure that they are
really right for you.

TO BE WITH ART IS ALL WE ASK.

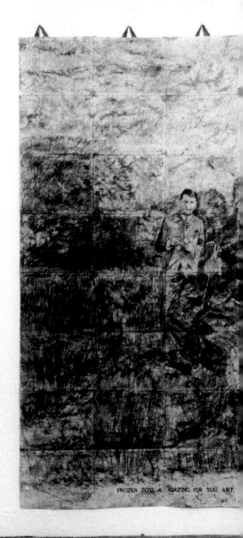

FROZEN INTO A GAZING FOR YOU, ART.

19

To be with Art is All We Ask...
Gilbert & George
1970

Oh Art, what are you? You are so strong and powerful, so beautiful and moving. You make us walk around and around, pacing the city at all hours, in and out of our Art for All room. We really do love you and we really do hate you. Why do you have so many faces and voices? You make us thirst for you and then to run from you escaping completely into a normal life: getting up, having breakfast, going to the work-shop and being sure of putting our mind and energy into the making of a door or maybe a simple table and chair. The whole life would surely be so easeful, so drunk with the normality of work and the simple pleasures of loving and hanging around for our lifetime. Oh Art where did you come from, who mothered such a strange being? For what kind of people are you: are you for the feeble-of-mind, are you for the poor-at-heart, are you for those with no soul? Are you a branch of nature's fantastic network or are you an invention of some ambitious man? Do you come from a long line of arts? For every artist is born in the usual way and we have never seen a young artist. Is to become an artist to be reborn, or is it a condition of life? Coming slowly over a person like the daybreak. It brings the art-ability to do this funny thing and shows you new possibilities for feeling and scratching at oneself and sur-roundings, setting standards, making you go into every scene and every contact, every touching nerve and all your senses. And Art we are driven by you at incredible speed, ignorant of

the danger you are pushing and dragging us into. And yet Art, there is no going back, all roads go only on and on. We are happy for the good times that you give us and we work and wait only for these titbits from your table. If you only knew how much these mean to us, transporting us from the depths of tragedy and black despair to a beautiful life of happiness, taking us where the good times are. When this happens we are able to walk again with our heads held high. We artists need only to see a little light through the trees of the forest, to be happy and working and back into gear again. And yet, we don't forget you. Art, we continue to dedicate our artists' art to you alone, for you and your pleasure, for Art's sake. We would honestly like to say to you, Art, how happy we are to be your sculptors. We think about you all the time and feel very sentimental about you. We do realise that you are what we really crave for, and many times we meet you in our dreams. We have glimpsed you through the abstract world and have tasted of your reality. One day we thought we saw you in a crowded street, you were dressed in a light brown suit, white shirt and a curious blue tie, you looked very smart but there was about your dress a curious wornness and dryness. You were walking alone, light of step and in a very controlled sense. We were fascinated by the lightness of your face, your almost colourless eyes and your dusty-blonde hair. We approached you nervously and then just as we neared you you went out of sight for a second and then we could not find you again. We felt sad and unlucky and at the same time happy and hopeful to have seen your reality.

We now feel very familiar with you, Art. We have learned from you many of the ways of life. In our work of drawings, sculptures, living-pieces, photo-messages, written and spoken pieces we are always to be seen, frozen into a gazing for you. You will never find us working physically or with our nerves and yet we shall not cease to pose for you, Art. Many times we would like to know what you would like of us, your messages to us are not always easily understood. We realise that it cannot be too simple because of your great complexity and all-meaning. If at times we do not measure up or fulfil you wishes you must believe that it is not because we are unserious but only because we are artists. We ask always for your help, Art, for we need much strength in this modern time, to be only artists of a life-time. We know that you are above the people of our artist-world but we feel that we should tell you of the ordinariness and struggling that abounds and we ask you if this must be. Is it right that artists should only be able to work for you for only the days when they are new, fresh and crisp? Why can't you let them pay homage to you for all their days, growing strong in your company and coming to know you better? Oh Art, please let us all relax with you. Recently Art, we thought to set ourselves the task of painting a large set of narrative views descriptive of our looking for you. We like very much to look forward to doing it and we are sure that they are really right for you.

TO BE WITH ART IS ALL WE ASK.

FROZEN INTO A GAZING FOR YOU ART 1970 | 280 x 181 cm (110 ¼ x 71¼ in)
from TO BE WITH ART IS ALL WE ASK …

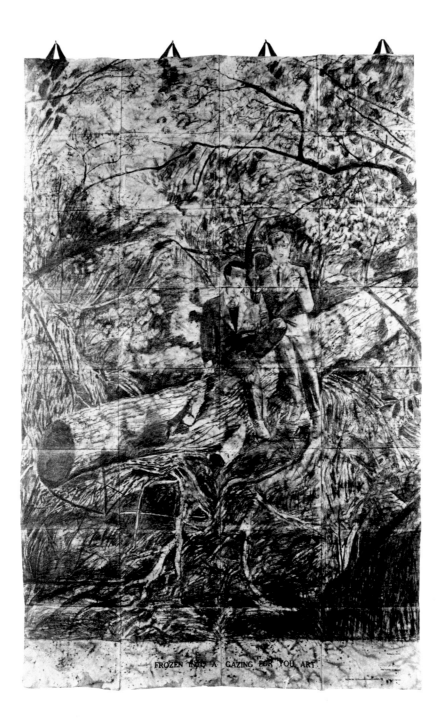

FROZEN INTO A GAZING FOR YOU ART.

RADICALS & PROGRESSIVES

Gilbert & George's ardent faith in art as redemption and as universal language for the common man echoes back to the thinking of many nineteenth-century British reformers ('It is for this reason that we have dedicated our hands, legs, pens, speech, and our own dear heads to progress and understanding in art', is the caption of another early charcoal-on-paper sculpture). And predictably, the look of their art and of their house is no less saturated in the sensibilities of nineteenth-century radicals and progressives. In 1945 the architectural historian John Summerson wrote an essay on William Butterfield, arguably the harshest and, by inherited standards of harmony and order, aggressively tasteless of Victorian architects. The title of Summerson's study, a landmark in the enthusiastic rediscovery of the strange pleasures of this then maligned chapter of art history, was 'The Glory of Ugliness', a phrase that neatly sums up Gilbert & George's own emotional and visual embrace of the past. In fact, their house on Fournier Street, located dead centre in *Fournier World* (1998), a picture that offers detailed close and far maps of their neighbourhood, is a museum of exactly this kind of art and thought. As avid collectors, they have

accumulated both classics and obscurities. A huge, immaculately polished table sports a spiky, brassy anthology of traditional nineteenth-century liturgical objects that would make most people of sensibility cringe in horror. The library features a number of rare books including the first folio edition of Owen Jones's *Grammar of Ornament* (1856), whose obsessively complex, symmetrical patterns and shrill colours might have nurtured Gilbert & George's work, much as Jones's zeal for the populist potential of prefabricated decoration is a prophesy of their ambition to make art for the masses.

Then there is their collection of furniture, ceramics, glass and metalwork by Jones's disciple Christopher Dresser, who also embraced the industrial revolution, designing awkward-looking coat racks, teapots and chairs that, rather than being conventionally beautiful, offer rugged, original inventions. For Dresser, function should determine form, even if the results were ungainly, and new factory-made materials such as cast iron should be used, the better to launch an aesthetic and social revolution that could at last penetrate the homes of the lower classes. Gilbert & George's tiny backyard boasts uncomfortable cast-iron benches and also offers a startlingly angled, close-up view of Christ

Church Spitalfields's steeple by Nicholas Hawksmoor. Admirers of harmonious Georgian buildings usually averted their eyes from this eighteenth-century British architect; but the very reason that had made him an outcast in his own day – his dissonant, eccentric experiments with a classical vocabulary – turned him, by the mid-twentieth century, into a cult figure who had prophesied the originality of Victorian architects. This is a happy location for those who, like Gilbert & George, admire the diversity so abundant in London. It is no accident that in *Black Church Face* (1980, fig. 25), the sacred vista behind the enormous image of faith that stares into our eyes is the apse of St Mary Abbots Church, Kensington, built by George Gilbert Scott, the architect of London's most famous and once-scorned Victorian monument, the Albert Memorial on the edge of Hyde Park. A luminous crown of Victorian stained glass, the geometries of which have often left their mark on Gilbert & George's patterns, completes the black worshipper's head. Here we might also remember some of Owen Jones's principles for success as outlined in the *Grammar of Ornament*, such as 'Colours should never be allowed to impinge on each other' or 'All ornament should be based upon a geometric construction.' (We can imagine

Gilbert & George nodding in approval of these aesthetic commandments.)

At times the grime and misery of city life are also to be found in Gilbert & George's pictures. Their world-weary but mechanized living sculptures moving to the repeated sounds of Flanagan and Allen's music-hall song *Underneath the Arches* (1932) offers two robotic entertainers who evoke a long tradition of depicting lower-class suffering and urban homelessness in art (1970, fig. 3). The shelter of London's bridges was a familiar scene from Victorian moral narratives; in the last painting of Augustus Egg's three-part *Past and Present* (1858), a drama of marital infidelity and its punishment deposits the destitute sinner underneath the arches of a bridge near the Strand. And Gilbert & George's monotonous labour in *Underneath the Arches* – an infinity of repetition – resonates in Gustave Doré's illustrations to Blanche Jerrold's *London* (1872), in which a Dantesque trip to the city's elegant public heavens and poverty-stricken hells includes the nightmarish scene of a round of inmates taking their daily exercise in the circular courtyard of Newgate Prison. It is no surprise also that one-time London resident Vincent van Gogh made a copy after Doré's print of this regimented human circle of despair. A similar image also

appears at the end of another Victorian narrative series, William Frith's *The Race for Wealth* (1877–80), as a moralizing finale for a swindling financier titled *Retribution*.

Through these pictures, it is possible to see Gilbert & George's fascination with the cruel, mechanized disciplines of work and punishment familiar to western society. They are vigilant observers of the depths of the social scene, from wage-slaves and drunks to street children and beggars, resurrecting the famous duo of Thomas Carlyle and the Reverend John Frederick Maurice who stand at the right of Ford Madox Brown's epic cross-section of the city's layered society, *Work* (1852–65), observing, like visitors from another planet, a vast human cosmos that, in modern terms, runs the gamut from heaven to hell. It is telling that one of Gilbert & George's possessions, a picture titled *The Flaming Ramparts of the World* (1901), by the relatively obscure late Victorian artist (and designer of stained glass) Reginald Hallward, sometimes thought to be the model for Wilde's Basil Hallward in *Dorian Gray*, runs to the opposite extreme. Here the earthbound grit and misery of lower-class life is countered by an apocalyptic, visionary art of Blakean proportions, taking the viewer to the gates of a supernatural world light-years away from contemporary urban fact. It is this polarity

of heaven and hell, of the here-and-now and the great beyond that constantly animates Gilbert & George's imagination and art.

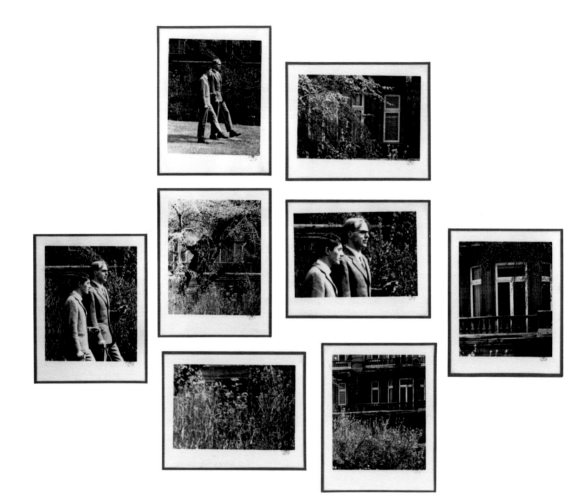

7 EIGHT-PART NATURE PHOTO PIECE 1971 | 80 x 94 cm (32 x 37 in)

We felt that ourselves as Living Sculptures was as much as we wanted to say to people. We were more shy of our own feelings, much less worldly at that time. Innocent in some ways, and ourselves with a background either nature …
Or inside the house.
Or in a bar, then we became more worldly. And more disturbed.
1981

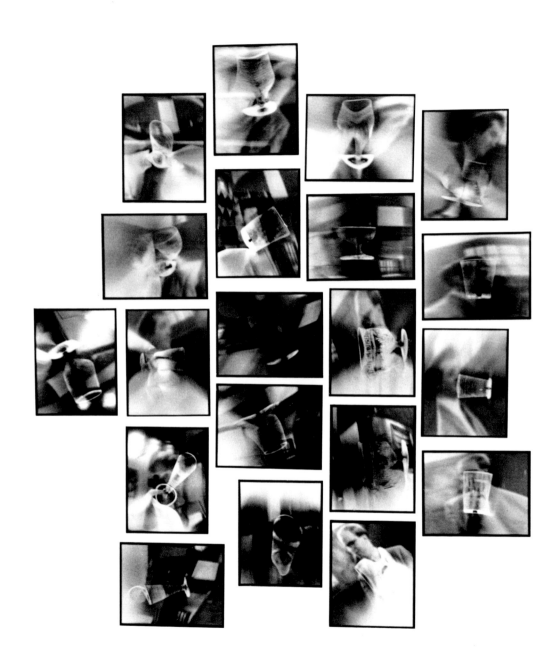

8 SLIPPERY GLASSES 1972 | 135 x 117 cm (53 x 46 in)

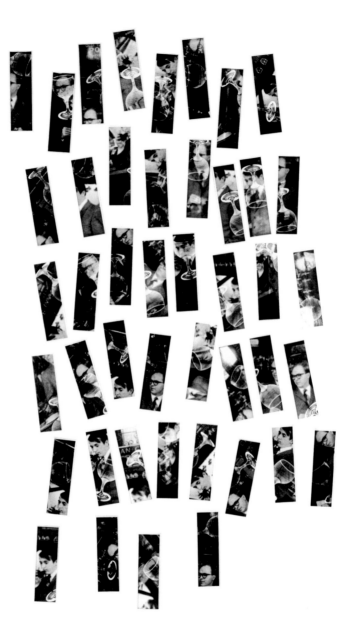

9 RAINING GIN 1973 | 197 x 114 cm (78 x 45 in)

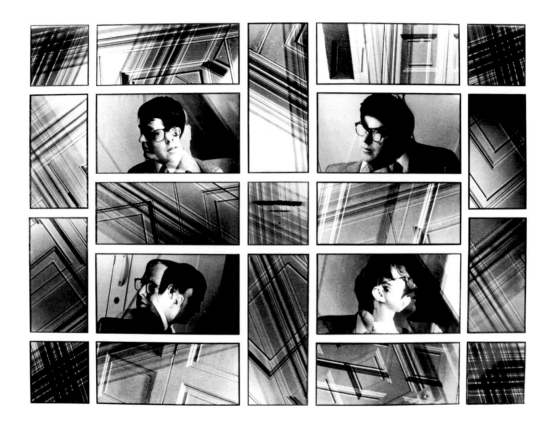

10 DARK SHADOW No. 6 1974 | 151 x 206 cm (60 x 81 in)

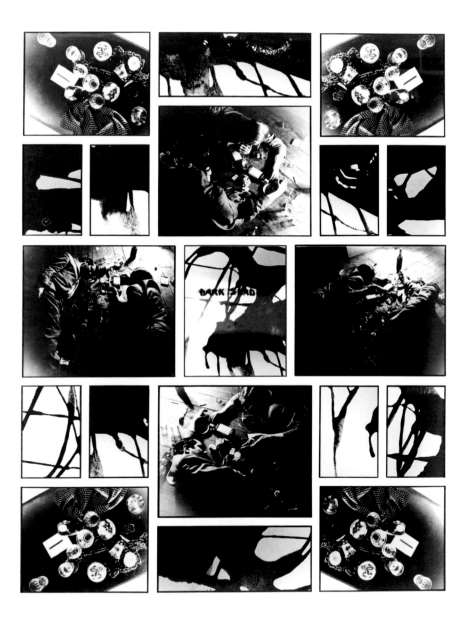

11 DARK SHADOW No. 9 1974 | 212 x 166 cm (84 x 66 in)

Gilbert and George have a wide range of sculptures for you – singing sculpture, interview sculpture, dancing sculpture, meal sculpture, walking sculpture, nerve sculpture, cafe sculpture, and philosophy sculpture.

1970

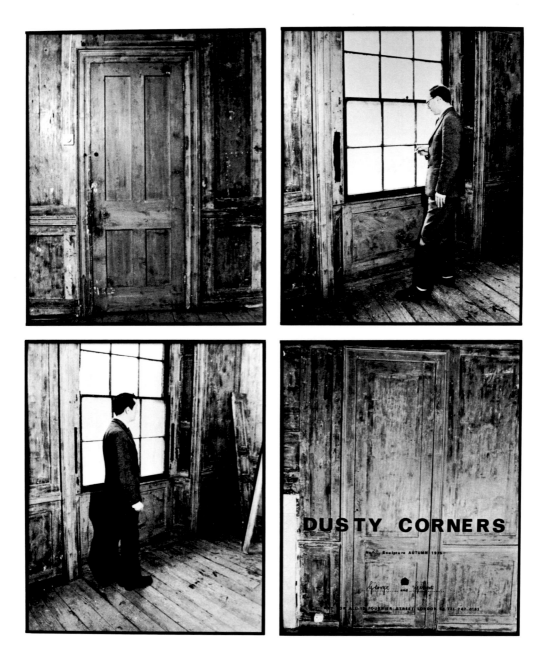

12 DUSTY CORNERS No. 20 1975 | 122 x 102 cm (48 x 40 in)

13 CHERRY BLOSSOM No. 7 1974 | 247 x 206 cm (97 x 81 in)

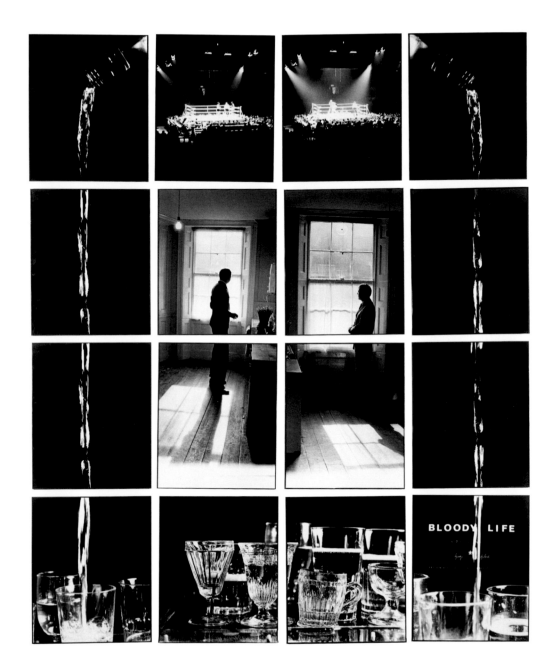

14 BLOODY LIFE No. 3 1975 | 247 x 206 cm (97 x 81 in)

Gilbert: In the early 1970s we did the Living Sculpture pieces. We came into contact with people through the art.

George: And we were no longer totally alone.... Alone in our work, but we saw people then. We drank. We were nearer to the violence of life than we are now or after we began to work on the house.

Gilbert: We had all the fighting pubs. Sometimes the police were called.

George: We always managed to get out of being arrested. Though we did get beaten up. And, in fact, we did end up in jail for the night. Twice. People seemed to find our stance a bit aggressive.

Gilbert: Freedom. We were after that.

George: The violence shows in *Cherry Blossom* and *Bloody Life*. Then our work became more sterile.

Gilbert: It's what we wanted then.

1986

George: We had already started to sign our names in red. Now we tried to find ways of using the colour red in the pieces.

Gilbert: We were looking for a more aggressive, more powerful image. Red has more strength than black. Black and white is powerful but red on top of it is even more so. It's louder.

George: The violence of the East, the extreme discipline of martial arts in the Orient fascinated us. The name *Cherry Blossom* originated in that fascination.

1986

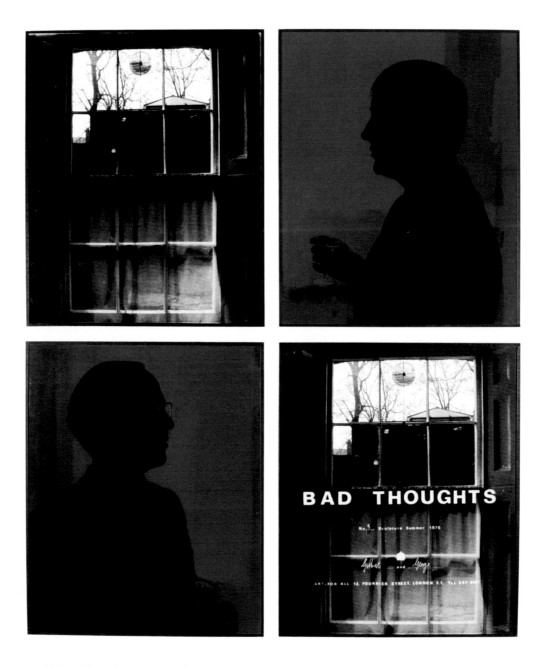

15 BAD THOUGHTS No. 9 1975 | 122 x 102 cm (48 x 40 in)

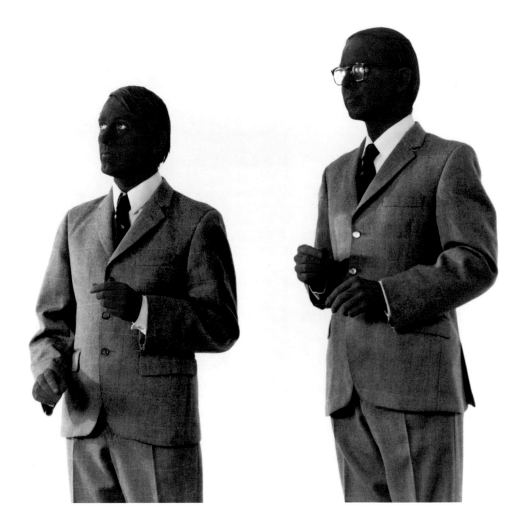

We are only human sculptors in that we
get up every day, walking sometimes,
reading rarely, eating often, thinking always,
smoking moderately, enjoying enjoyment,
looking, relaxing to see, loving nightly,
finding amusement, encouraging life,
fighting boredom, being natural, daydreaming,
travelling along, drawing occasionally, talking
lightly, tea drinking, feeling tired, dancing
sometimes, philosophising a lot, criticising
never, whistling tunefully, dying very slowly,
laughing nervously, greeting politely and
waiting till the day breaks.
1970

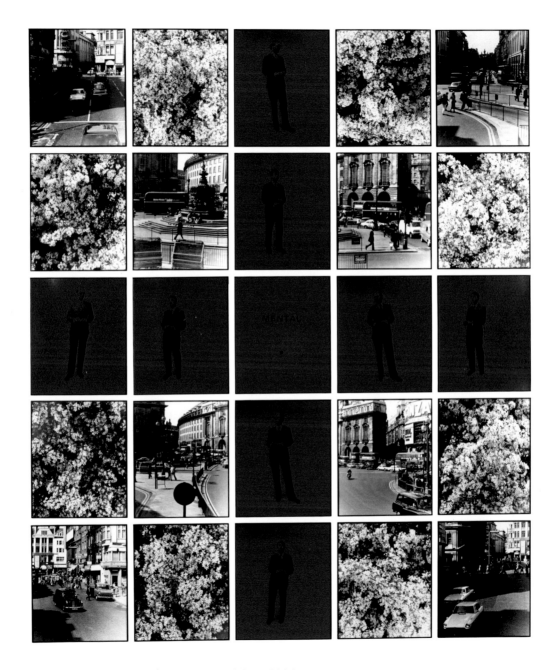

17 MENTAL No. 3 1976 | 308 x 258 cm (121 x 102 in)

CITY & COUNTRY

Throughout the nineteenth century, another polarity, the growing and often poignant distance between city and country, loomed large. Modern city life, with its crush of new buildings, be they railway stations, workers' homes, factories or offices, and with its welling populations of the newly rich together with the derelict and the hopeless, gradually transformed what lay beyond the city and suburbs into a pastoral fantasy, a pre-industrial Garden of Eden still free from soot and smoke. Many Victorian painters, and Impressionists like Monet and Renoir, would switch from scenes of urban congestion and bustle to what would become the soothing antidote to city life, a landscape still innocent of the ways of the modern world. Victorian artists immerse the viewer in both realms, alternating between the enduring solace of a verdant paradise, where aged oak trees, grazing sheep, and burgeoning spring flowers could still be found, and the interior of a crowded London omnibus or a scene of fallen women contemplating suicide on the banks of the Thames. Gilbert & George resurrected this twofold legacy in both epic and modest dimensions. Their passion for nature was revealed as early as 1970 in their startlingly large,

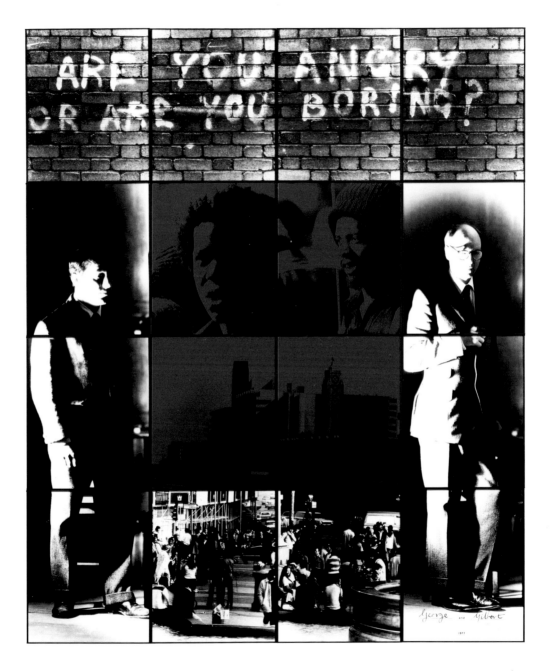

ARE YOU ANGRY OR ARE YOU BORING? 1977 | 241 x 201 cm (95 x 79 in)

George: Our subject matter is the world. It is the Pain. Pain. Just to hear the world turning is Pain, isn't it? Totally, every day, every second. Gilbert: Our inspiration is all those people alive today on the planet, the desert, the jungle, the cities. We are interested in the human person, the complexity of life.

1990

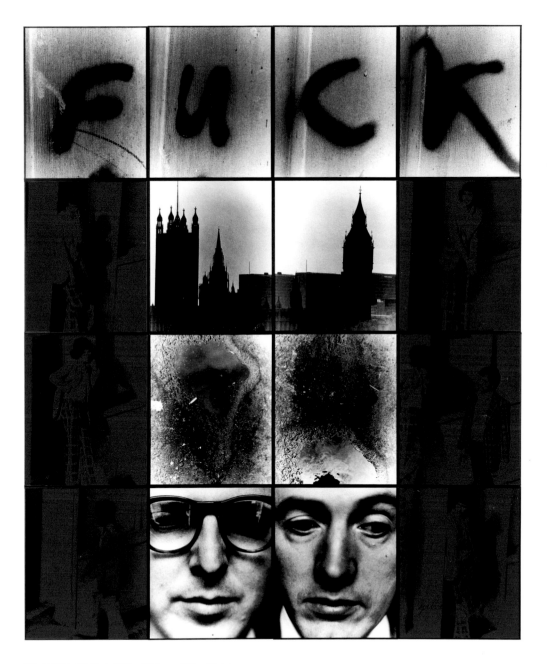

19 FUCK 1977 | 241 x 201 cm (95 x 79 in)

charcoal-on-paper sculptures (fig. 5) showing the two of them, in their immaculate city clothing, wandering through the enchantments of a woods recorded with a fanatical exactitude that can rival the Pre-Raphaelite Brotherhood's scrutiny of botanical detail. That it might be possible to see these endlessly precise charcoal renderings of bark, branch and leaf as sharp-focus images of nature in its thrilling diversity and confusion is borne out soon after in *Eight-Part Nature Photo-Piece* (1971, fig. 7), in which Gilbert & George feature exactly the same theme: the two of them, urban intruders, strolling side by side through the enchanting infinities of a landscape seemingly remote from the city in both time and space. At times, this intensity of scrutiny can reach life-and-death extremes. In *Intellectual Depression* (1980, fig. 26), the gnarled, skeletal branches of a leafless tree are silhouetted against a lethally artificial solar yellow. This close-up vision of the cycles of nature precedes Gilbert & George's later macro- and microcosmic views of a world outside the city, whether in the frequent magnifications, at once scientific and dreamlike, of flowers, insects and, more recently, of bodily fluids (figs 53, 60, 61, 62), or in the awesome renderings of apocalyptic landscapes, such as *Flow* (1988, fig. 51), one of the 'For AIDS' pictures made to

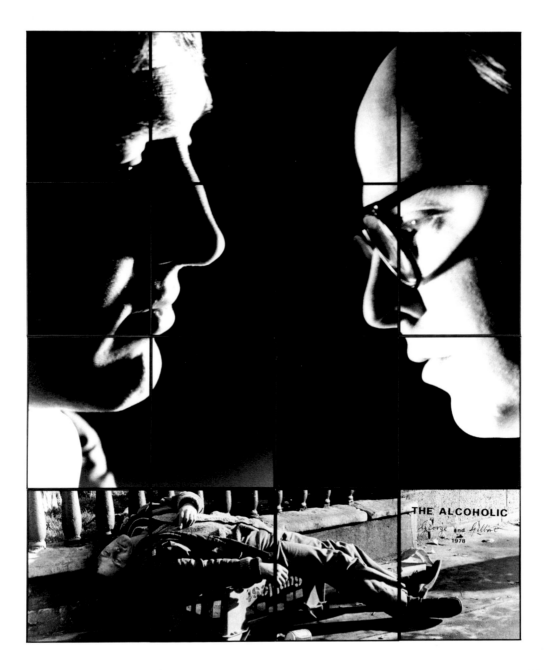

20 THE ALCOHOLIC 1978 | 240 x 200 cm (94½ x 78¾ in)

commemorate the death of their friend, the poet and artist David Robilliard. Here, with an ultimate sweep from earth to sky, the viewer is rushed across the British countryside to the brink of a sun setting on eternity.

Their documentation of the city is no less intense in their images of London. Sky-borne views and street-side observations carry the mark of a nineteenth-century novelist or a modern journalist recording the mood, the look and feel of the city's architecture or the ugly truths of urban life. They are enthralled by the giant pulse of the great city, as in *Day-Time* (1986, fig. 47), where, what looks like a dreamlike perspective rush, split at an impossible tilt over the artists' huge, still-sleeping bodies, captures an endless march of city workers in suits, who, with the sun, announce a new working day with clockwork predictability. London's landmarks, old or new, are constant factors in Gilbert & George's imaginary terrain. In *Mental No.3* (1976, fig. 17), they oppose country and city in checkerboard vignettes that shift from close-ups of foliage to views of Piccadilly Circus; and in the fifteen-feet-wide *Here and There* (1989, fig. 55), the universe as watched from afar by the two diminutive artists, who float and kneel on a sewer cover turned into their private UFO, is divided into two parts, left and right, city and country, by

a handsome black athlete of giant proportions. Often, we feel we are looking at an updated version of *Gulliver's Travels*, watching extraterrestrial visitors exploring the city with fresh and startled eyes. In *Drunk with God* (1983, fig. 38) Gilbert & George range in size from pygmies to giants, hovering, pointing, flying over a drunken, psychedelic nightmare whose earthbound level is punctuated by regiments of militant street boys and the colossal towers of Nelson's Column and Big Ben.

In Gilbert & George's world, buildings and streets constantly juggle past and present, making for jarring contrasts. On the one hand, there are new clusters of high-rise, featureless office buildings, whose modular grid structures are often reflected in the artists' own insistent rectangular patterning; and on the other, there are such venerable monuments as St Paul's Cathedral, Westminster Abbey and the statue of Eros in Piccadilly Circus. They are the stuff of London souvenir postcards, which became, quite literally, the medium of many of their works, notably *Twenty-Five Worlds* (1989), ruglike compositions of 225 postcards, eight feet high by almost six feet wide. These collisions between public and private in city life can be found throughout their art. What could make one feel more acutely the ache of urban

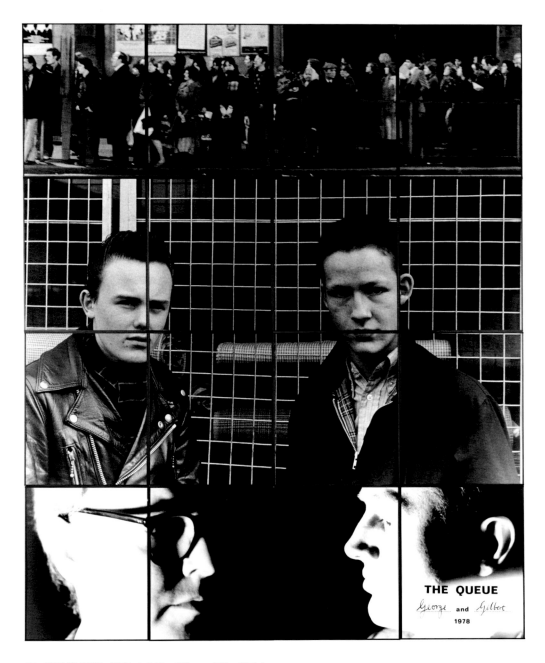

THE QUEUE

George and Gilbert

1978

21 THE QUEUE 1978 | 241 x 201 cm (95 x 79 in)

We look at the raw material of life. We prefer to come out of the front door, it's been raining, there's a puddle there, and there's a bit of vomit from a Chinese takeaway, there's a pigeon eating it, there's a cigarette end, and that's all there is. And then you know what it is.
1995

loneliness than the bleak, unfurnished rooms that imprison the artists in such pictures of 1975 as *Dusty Corners* (fig. 12) and *Bad Thoughts* (fig. 15), especially when a rectangle of blank light from the street outside penetrates these empty rooms? And what could be more of a reminder of a London winter than the view of Fournier Street during a snowfall (*Fournier Snow*, 1980, fig. 22)? But the convivial crushes of city life are also part of their reportorial coverage. Within the vast spectacle of anonymous throngs, there are an infinity of urban vignettes: the irregular frieze of people lined up, waiting, against a city wall, as in *The Queue* (1979, fig. 21); the rowdy communities of pub-crawlers, descendants of William Hogarth's *Beer Street* and *Gin Lane* (1751); or the anticipated pleasures of a crowded, snowy playground, as in *Winter Flowers* (1982, fig. 31).

Their role as compassionate, yet detached observers is indelibly defined in *The Alcoholic* (1978, fig. 20), a strange mixture of documentary fact and psychological fiction. Twinned as always, their giant, airborne heads look down like deities on a nameless drunk littering the street after the pubs have closed. It is an image that provides the moralizing coda to the earlier pictures of their own nightly binges, defined both in word – *Slippery Glasses* (1972, fig. 8),

Raining Gin (1973, fig. 9) – and in free-floating images whose tilted or falling patterns echo, in their shaky balance, the familiar theme of the joys and sorrows of the evening's escape into the pub, an escape that, in later works like *Flight* (1983, fig. 35), could transform them into moonwalkers. But the city streets can offer more alarming, heartbreaking sights, as in *Mad* (1980, fig. 24), a head-on confrontation, frighteningly larger than life-size, which leaves us afloat in the staring, desperate expression of one of the countless poor souls who wander the city, a subject more familiar to the world of Victorian philanthropy than to contemporary art. Teenage street boys, every one an individual, offer another survey of city life that can move from facts to fictions. At times, they can be dangerously chauvinistic, as in *Cocky Patriot* (1980, fig. 27), but elsewhere their gangs can be cast as an angelic chorus, as in *Hope* (1984, fig. 41), where they are both earthbound and heaven-borne. Graffiti also figures large in Gilbert & George's urban cosmos, particularly as dirty four-letter words scrawled in chalk on equally dirty walls. From these inscriptions – 'queer', 'suck', 'poof', 'cunt', 'cock' – they succeed in making upright, enduring symbols, as in the *Dirty Words* pictures (1977, figs 18, 19), where outscaled inscriptions, framing smaller images of the two

artists alone in the streets, transform their private and public experiences into impersonal coats-of-arms. And it should be remembered that, flouting art-school propriety, their early career as self-portraitists included a pair of magazine portraits inscribed in cutout letters: GEORGE THE CUNT and GILBERT THE SHIT (*Magazine Sculpture*, 1969, fig. 1). In this lowdown world, sex and desire seethe, both outside and inside the artists' eyes and viscera. Who but Gilbert & George could have assembled in billboard size the emblems of London's sex industry, the ads published for an international variety of hustlers (*Geography*, *West End*, *I Am*, 2001, figs 68, 69, 70)? Arranged with printing-press regimentation, these murals of sexual commerce, often as big as movie screens, capture in their word-strewn midst the ageing artists, wandering through these classified siren songs as if poised on the threshold of pleasure or damnation.

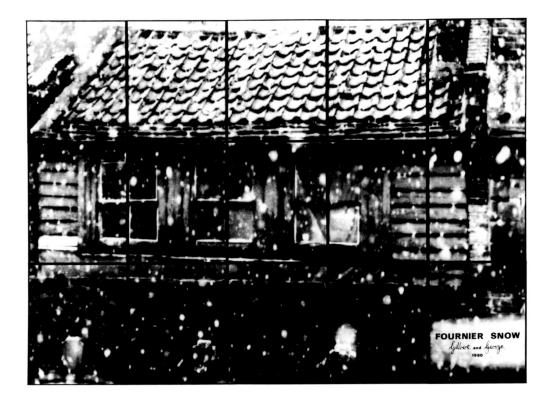

FOURNIER SNOW
Gilbert and George.
1980

22 FOURNIER SNOW 1980 | 181 x 250 cm (71 x 98 in)

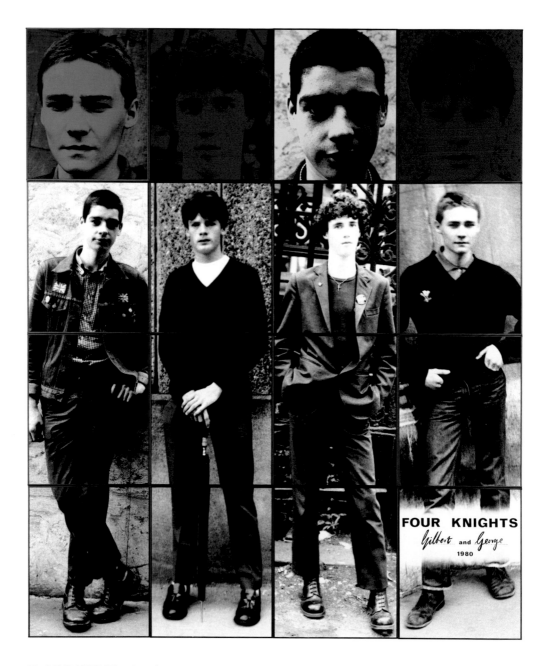

FOUR KNIGHTS
Gilbert and George
1980

23 FOUR KNIGHTS 1980 | 241 x 201 cm (95 x 97 in)

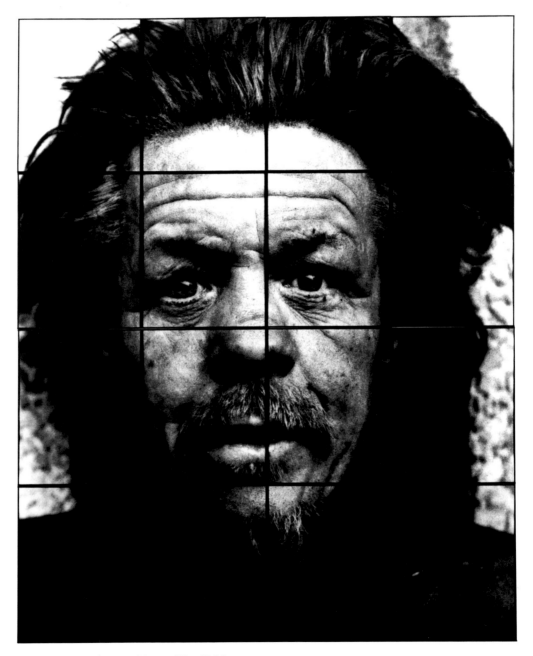

24 MAD 1980 | 241 x 201 cm (95 x 97 in)

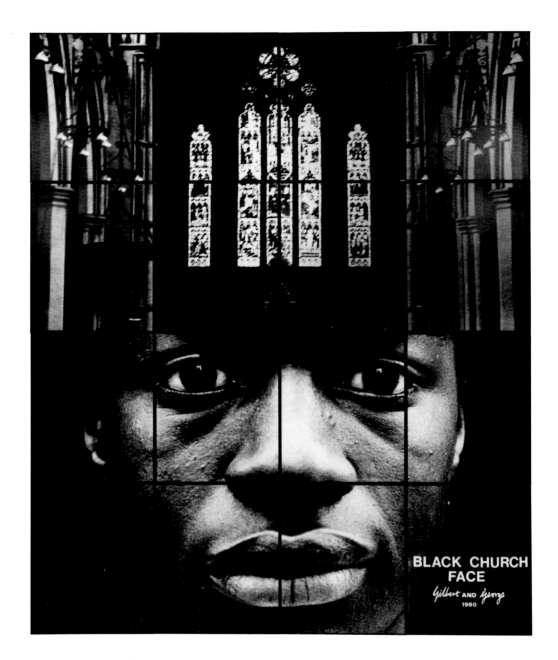

BLACK CHURCH
FACE

Gilbert AND George
1980

25 BLACK CHURCH FACE 1980 | 241 x 201 cm (95 x 97 in)

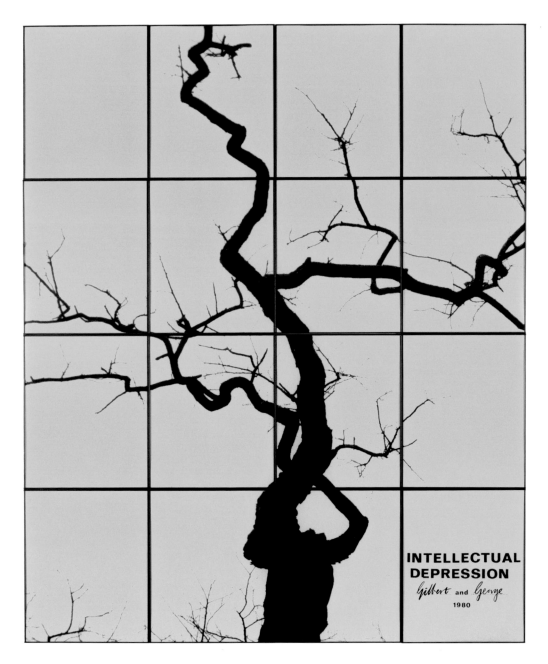

INTELLECTUAL
DEPRESSION
Gilbert and *George*
1980

26 INTELLECTUAL DEPRESSION 1980 | 241 x 201 cm (95 x 97 in)

27 COCKY PATRIOT 1980 | 181 x 351 cm (71 x 158 in)

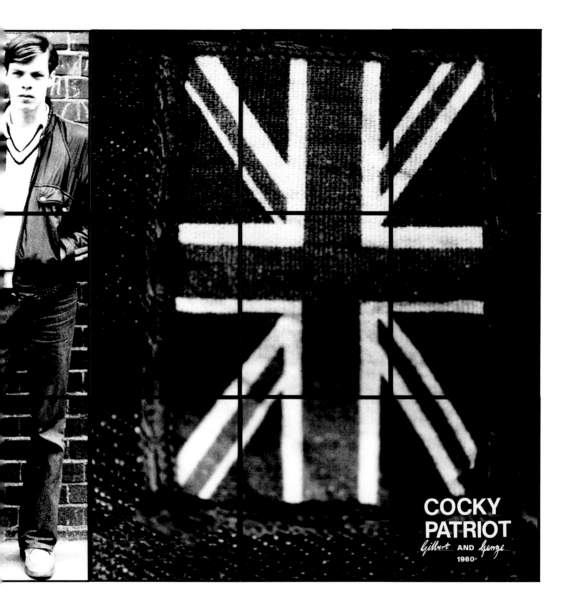

COCKY
PATRIOT
Gilbert AND *George*
1980

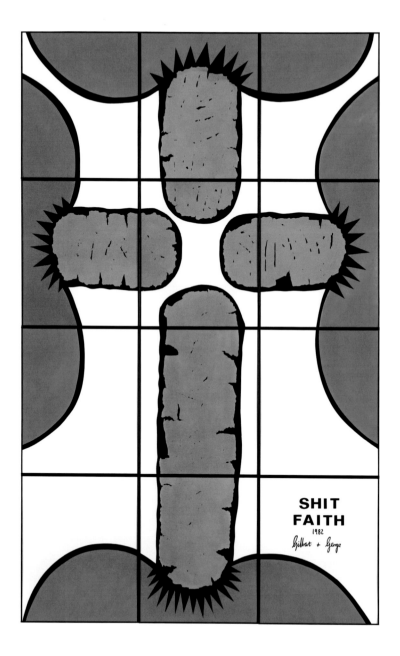

28 SHIT FAITH 1982 | 241 x 151 cm (95 x 59 in)

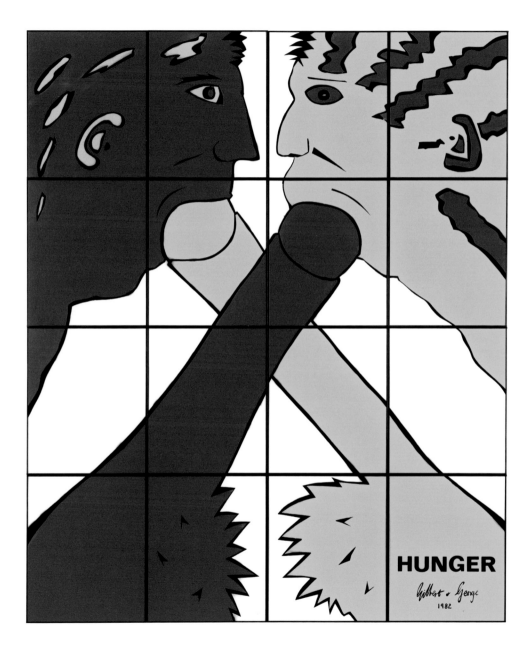

HUNGER

Gilbert & George
1982

29 HUNGER 1982 | 241 x 201 cm (95 x 97 in)

30 LIFE WITHOUT END 1982 | 422 x 1104 cm (166 x 434⅔ in)

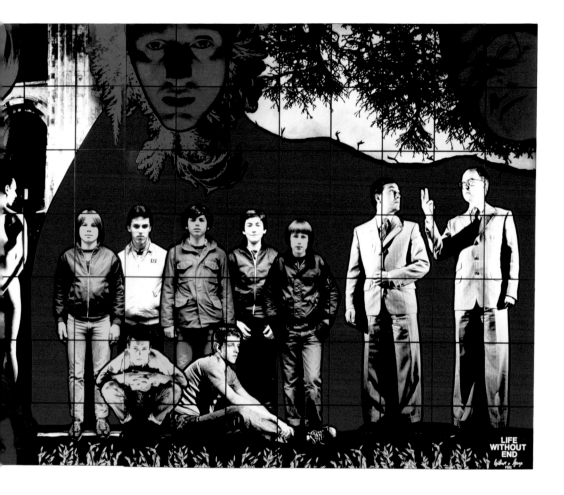

LIFE
WITHOUT
END

Gilbert & George
1982

69

We think of our art as just pictures, not as photographs. We're using photography, not being photographers. The question of our medium is more for the art profession than for the public. A normal person does think about such things. You see a picture, you want to know what it says.

1986

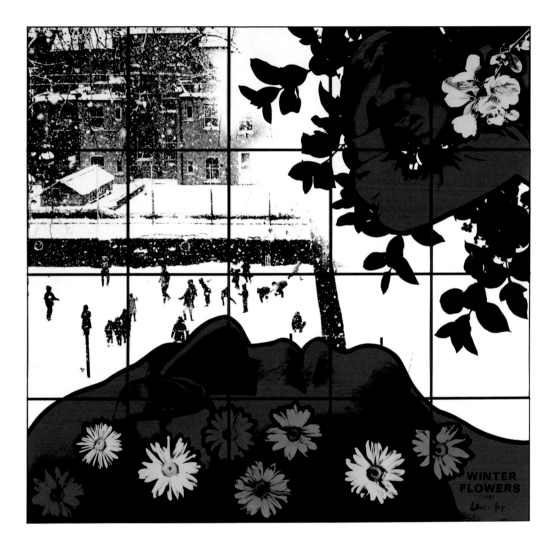

31 WINTER FLOWERS 1982 | 241 x 250 cm (95 x 99 in)

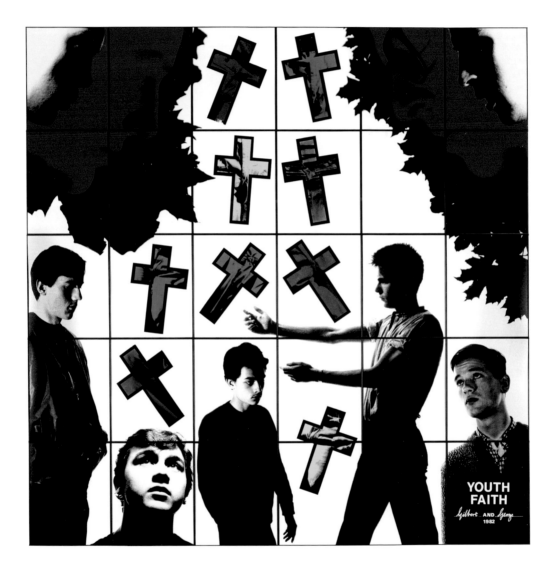

32 YOUTH FAITH 1982 | 302 x 301 cm (119 x 119 in)

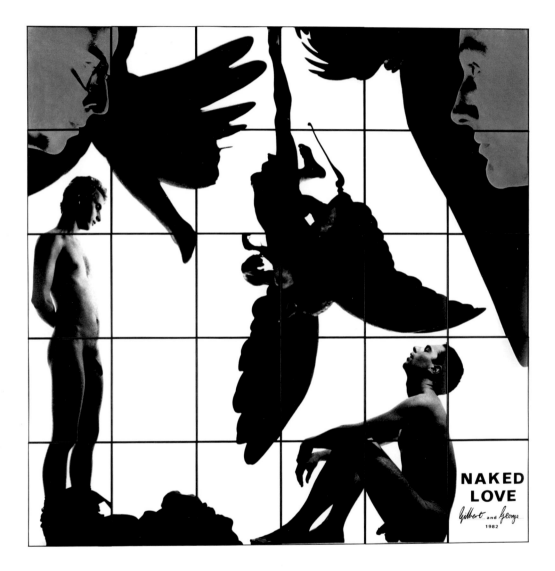

NAKED
LOVE

Gilbert and George
1982

33 NAKED LOVE 1982 | 302 x 301 cm (119 x 119 in)

34 STEPPING 1983 | 181 x 351 cm (71 x 138 in)

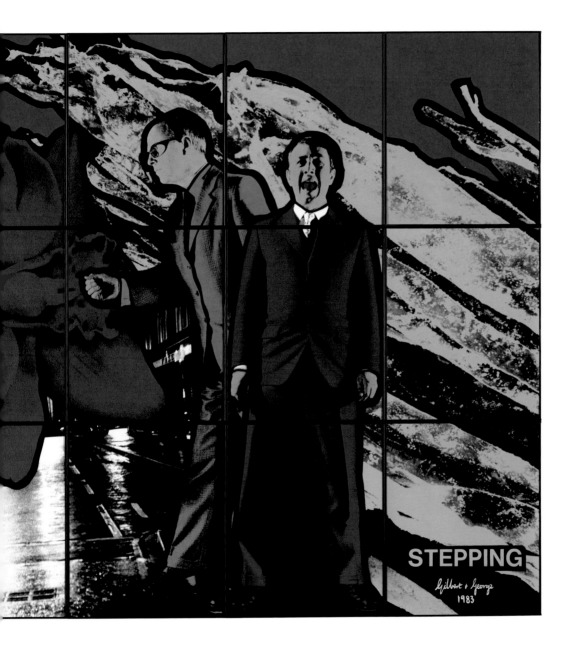

STEPPING

Gilbert & George
1983

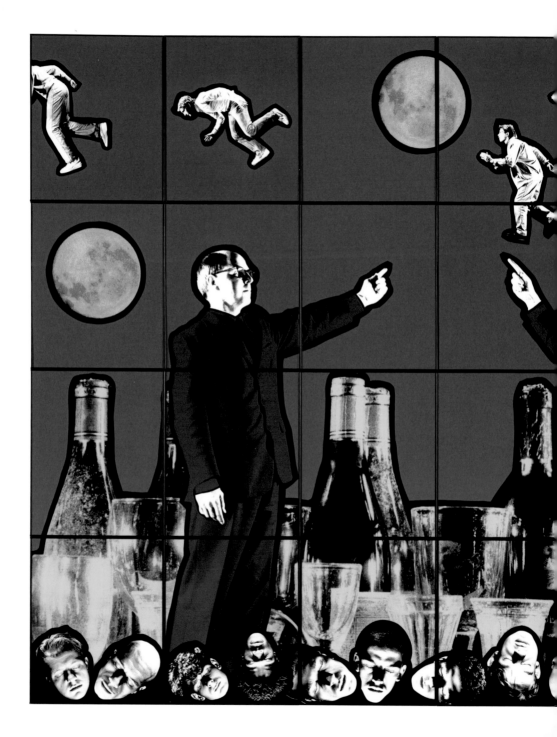

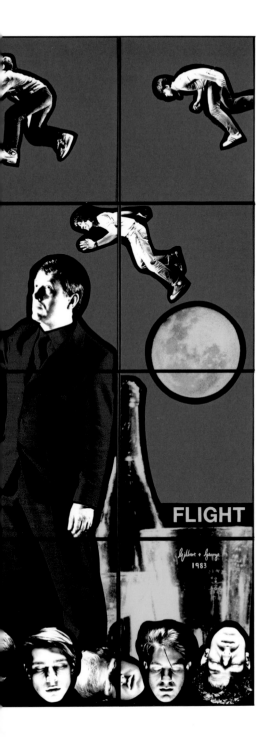

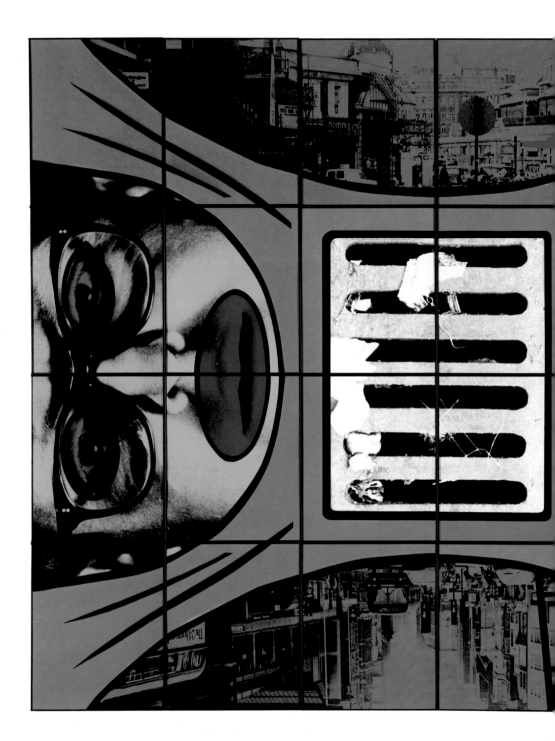

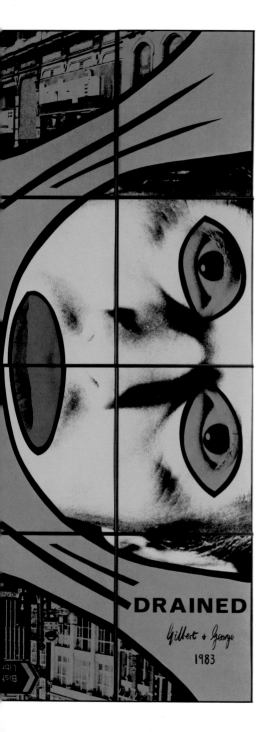

36 DRAINED 1983 | 241 x 301 cm (95 x 119 in) 79

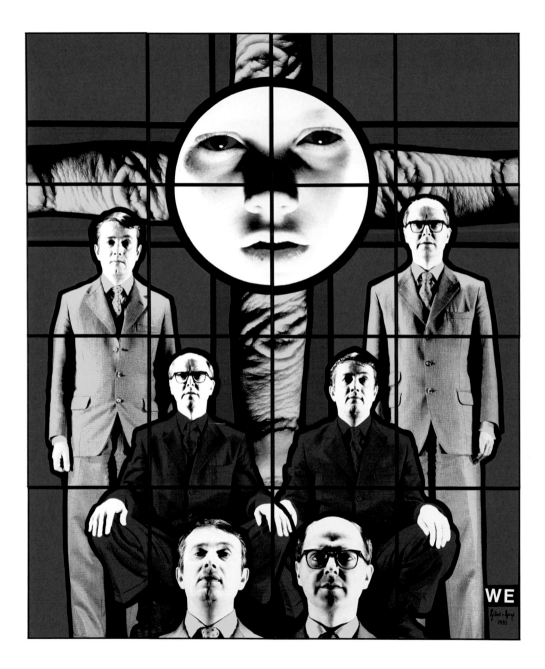

37 WE 1983 | 241 x 201 cm (95 x 97 in)

HEAVEN & HELL

Looking over more than three decades of Gilbert & George's art, it is clear that they move constantly from the world of the documentary present, literally seen through a camera lens, to a supernatural territory that, like so much art of the last two centuries, usurps traditional, shared religious concepts with private fantasies. Christianity itself is echoed, most often in blasphemous ways, transforming the toughest street boys into angels, cherubim or the religious militants of *Four Knights* (1980, fig. 23). Such visionary fusions of raw sex and exalted faith can shock or reassure any believer. *We* (1983, fig. 37) says it all. Its familiar Christian pattern is rigidly cruciform, but the martyred body of Christ on the cross is replaced by cropped, greatly enlarged views of four fingers, easily misread as penises, a variation of the gross offence already committed in *Shit Faith* (1982, fig. 28), with its cross-pattern of turds. At this strange shrine, spookily animated by a demonic, visionary face of white skin and red eyes inscribed in a perfect circle, the artists, in three rising tiers, stand like saints and worshippers. In *Down to Earth* (1989, fig. 54), the story of the Resurrection seems to be reinvented, as the souls of Gilbert & George rise from a

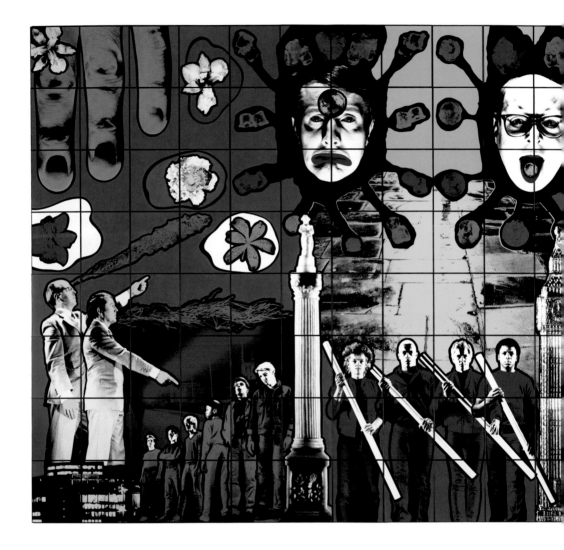

38 DRUNK WITH GOD 1983 | 482 x 1102 cm (190 x 434 in)

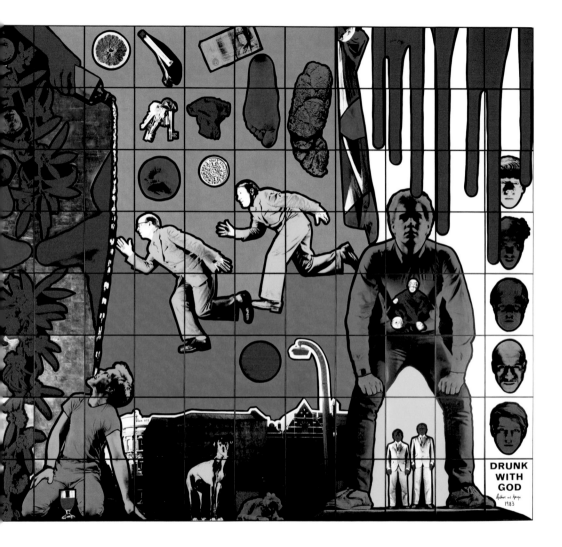

Christian graveyard to the fearful reincarnation of their huge, disembodied heads glowering at our terrestrial realm. In both *The Edge* and *Flow* (1988, figs 50, 51), we move from body to soul, from life to death, as the Lilliputian figures of the artists, perched on top of the gigantic knees of a male nude, take their places against the brink of eternity, a visionary sky that began as an image of stormy weather. This view of nature as a living symbol of our destinies can also, in the age of AIDS, turn malevolent. In the 1988 group of twenty-five pictures responding to the AIDS epidemic (works whose proceeds from their 1989 showing were donated to the British charity CRUSAID), the organic universe has been stricken by an evil red force in which rivers, shadows and drops of blood permeate and gradually destroy everything in nature. It is a plague that can attack dew drops (*Tears*, 1987, fig. 48), the white petals of daisies (*Flowered*, 1988, fig. 52), the veins of once-green leaves (*Pains*, 1988, fig. 49), and even the roads, woods and sun of the countryside in *Flow*.

The power of these images is the result of the artists' unbridled and uncensored imagination and of their fiercely simple colours and structures, which echo through the corridors of religious art. The analogy with stained glass,

especially the nineteenth-century kind, a medium whose lucid geometries, underscored by the patterns of leading, are reborn in the visible grids of Gilbert & George's rectangular modules. And their use of strident and clear colours, with their simple, printer's-ink palette of acidic primary and secondary hues, generally used as a synthetic translucence over an image, recall the incorporeal effects of Christian images embedded in luminous glass panes. Their art also bears memories of Christian altarpieces, as in *I Am* (2001, fig. 70), one of the *New Horny Pictures*, which might be likened to a huge iconostasis (some forty-five feet wide). But here, a celestial choir of saints is replaced by the ads of seventy-eight hustlers, a theme they varied in smaller versions that, as in *Geography* and *West End*, focus more narrowly on the sex trade's local geographical distribution. Heresy abounds, reaching a jolting extreme in *Urinal* (1991), in which their full-frontal naked selves and souls stand vigilant at a public urinal, the patterns of porcelain niches and cruciform plumbing merging seamlessly with a worshipper's view down the aisle of Southwark Cathedral. In *Life Without End* (1982, fig. 30), the artists usurp the role of pious patrons in medieval and renaissance devotional paintings, a role they also play in *Doers* (1984, fig. 39), where they worship in the

corner of a hallucinatory rush of street boys. Amidst these new versions of religious truths and passions – a universe of burgeoning nature and beautiful male youths – they kneel and pray to their own creation.

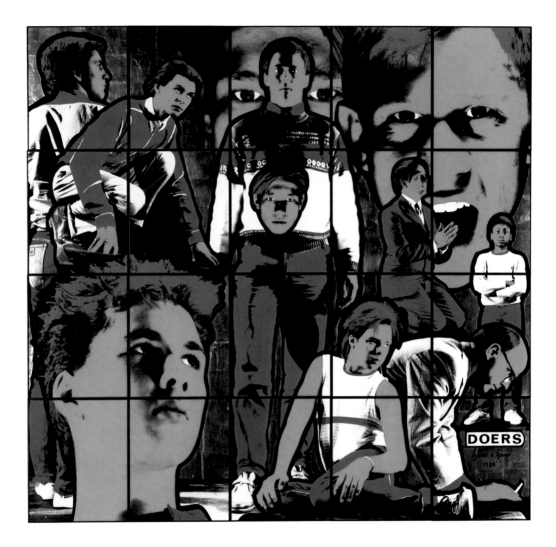

39 DOERS 1984 | 241 x 250 cm (95 x 99 in)

We are more miserable than anyone else we know. We think it is very important to be miserable, we don't believe that anyone made any progress through being cheerful. Civilisation is not 'advanced' by people lying on the beach with a gin and tonic. Everything is subservient to the art, in fact, and everything has to fit in around it. We try to clear out our life and empty it. We give all our feelings and thoughts and fears and dreads and hopes, straight into our pictures – you cannot be more open than that. There is hardly a subject of life that isn't universal that we haven't discussed in our work.
1990

40 DEATH from DEATH HOPE LIFE FEAR 1984 | 422 x 250 cm (166 x 99 in)

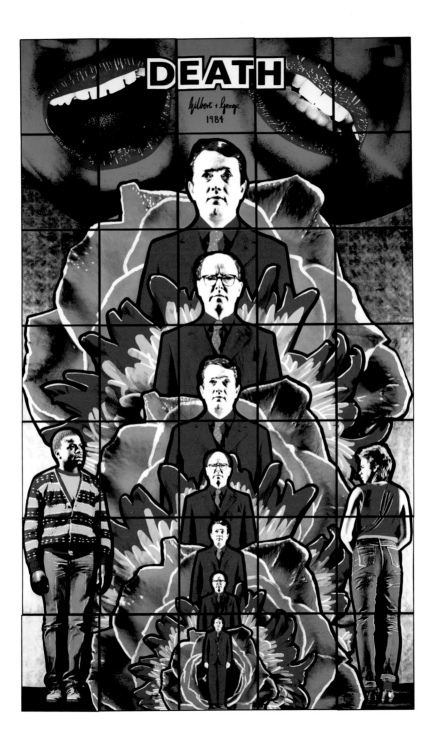

89

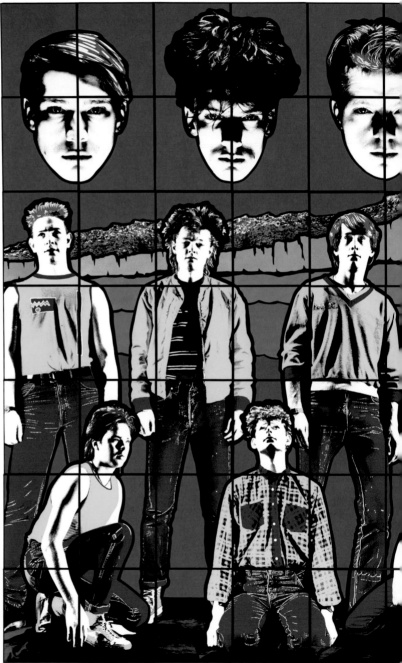

41 HOPE from
DEATH HOPE LIFE FEAR 1984
422 x 652 cm (166 x 257 in)

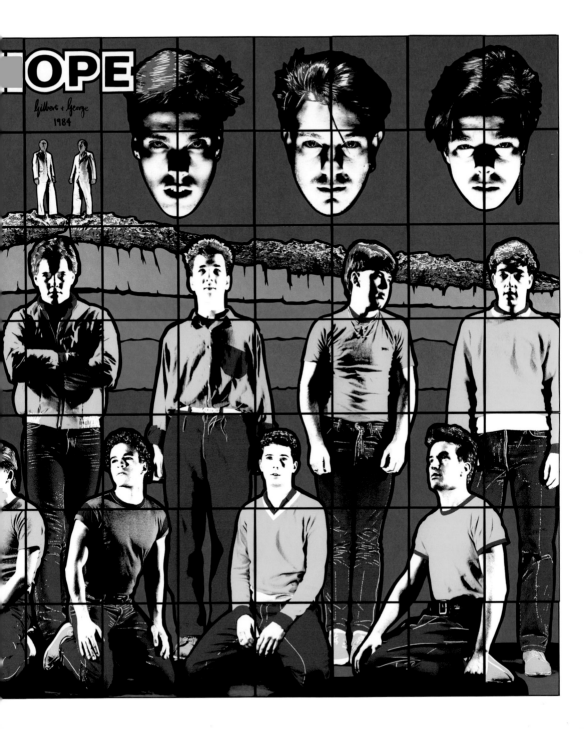

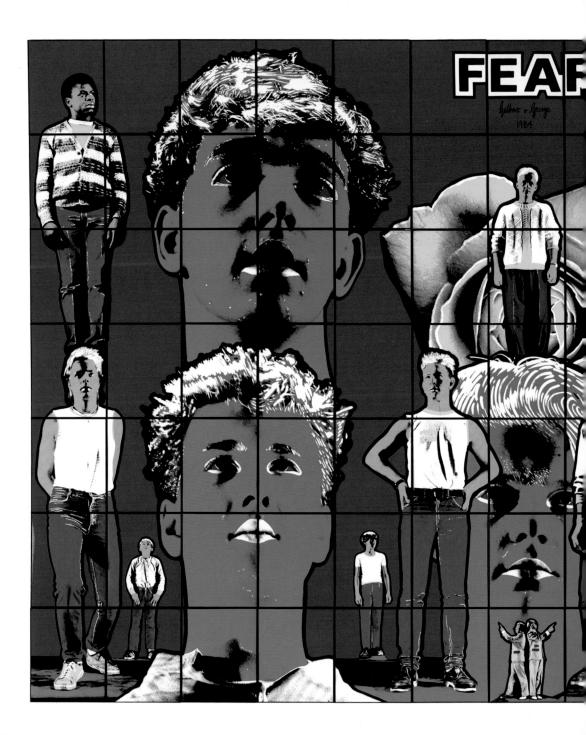

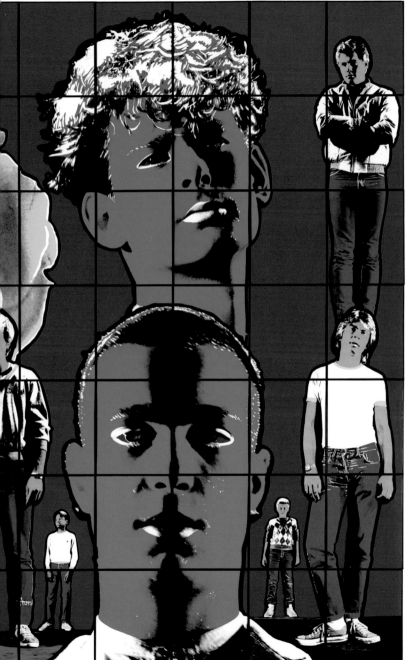

42 FEAR from
DEATH HOPE LIFE FEAR 1984
422 x 652 cm (166 x 257 in)

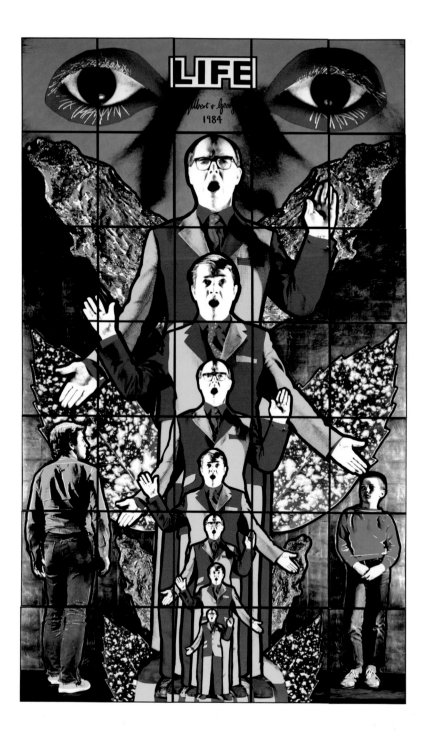

We think every single person is religious, to a certain degree. That's what we are, as well. We try to sort out what that means. Sometimes people are shocked by pictures of shit and so on, but we don't want to make them run from the gallery. We don't like that. We want to push forward in our art, so we must keep the viewer there. That's very important.

1986

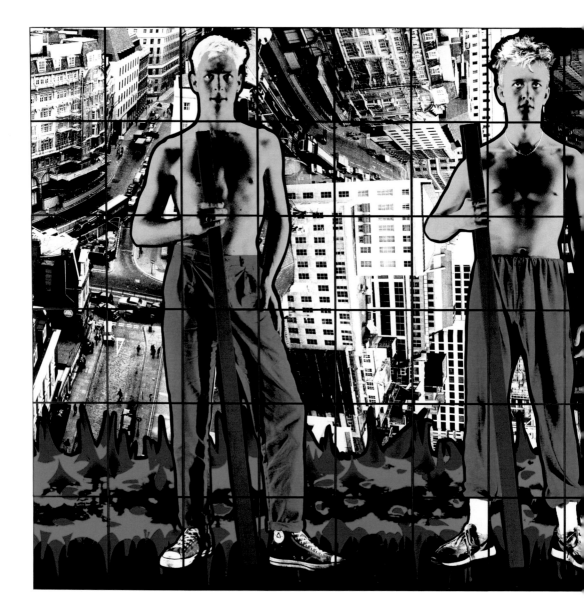

44 MILITANT from CLASS WAR MILITANT GATEWAY 1986 | 363 x 758 cm (143 x 298 ½ in)

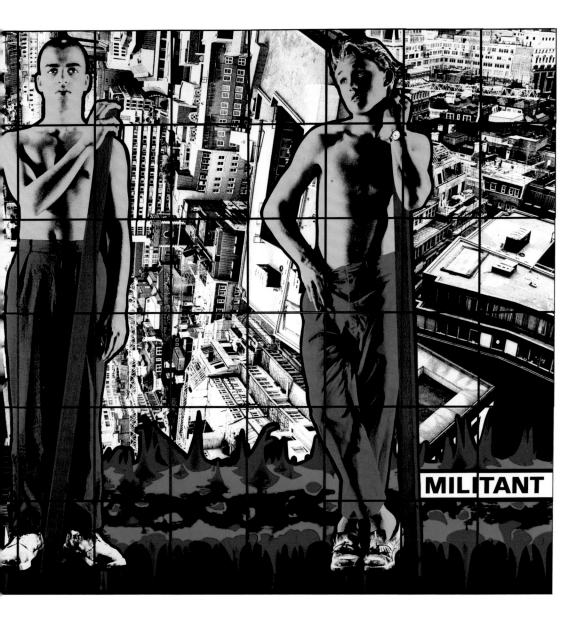

MILITANT

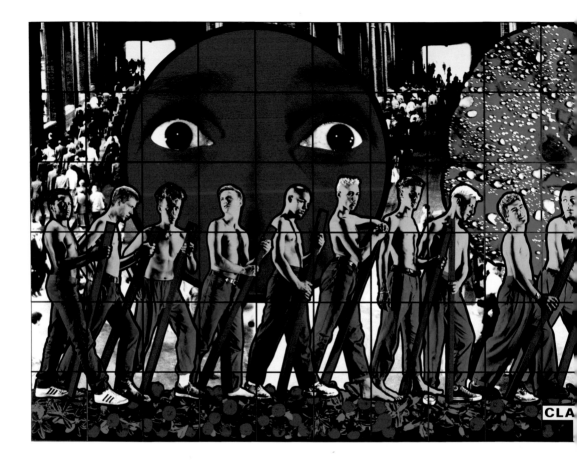

45 CLASS WAR from CLASS WAR MILITANT GATEWAY 1986 | 363 x 1010 cm (143 x 397 ⅔ in)

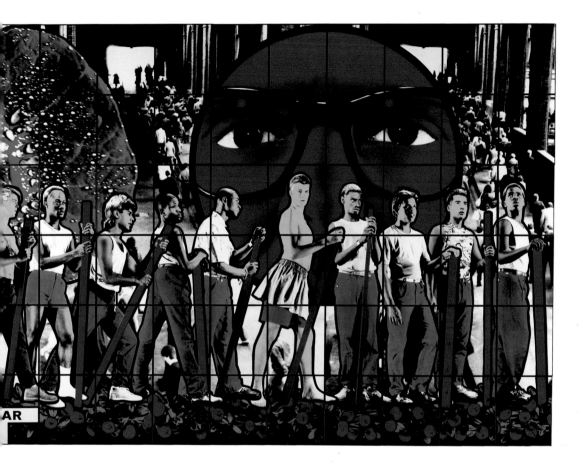

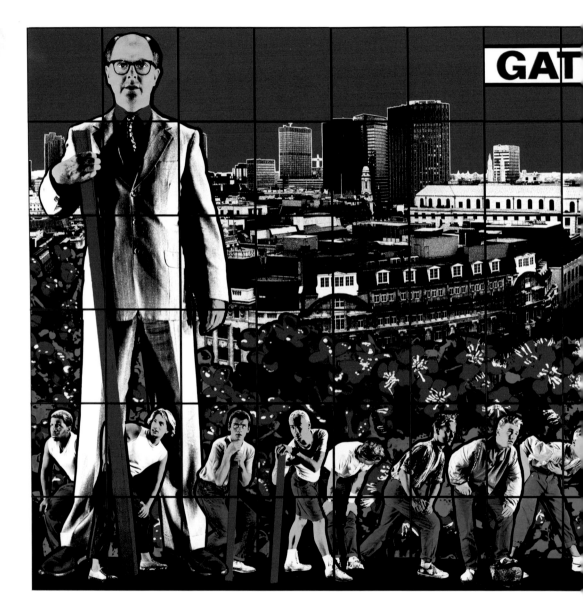

46 GATEWAY from CLASS WAR MILITANT GATEWAY 1986 | 363 x 758 cm (143 x 298 ½ in)

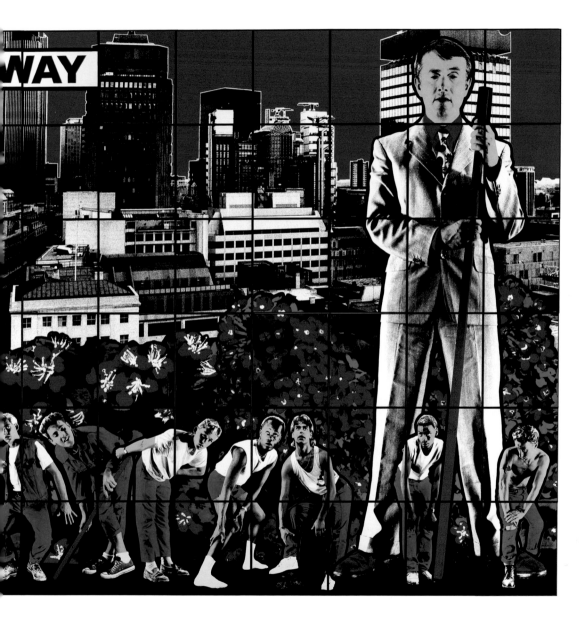

We always say the viewer is trying to find
themselves. They are not interested in art.
They are trying to find a way of feeling happier
within themselves. We really believe that.
They are all searching for themselves.
1995

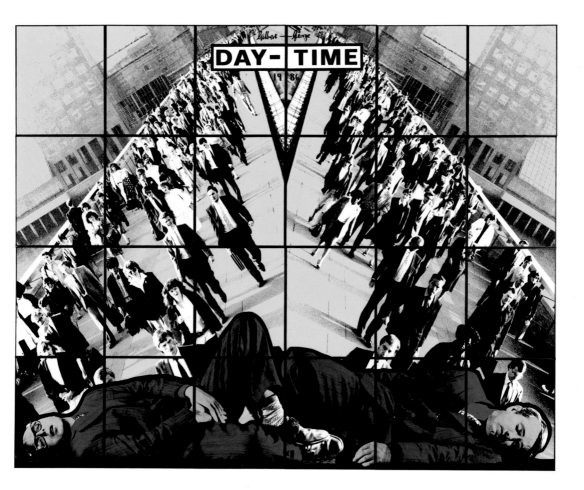

47 DAY-TIME 1986 | 241 x 301 cm (95 x 119 in)

Gilbert: We had some ordinary leaves and we tried to humanise them.

George: They are crying in a slightly different way. There are these two black holes which we like to think is like us. The rest is a void, an empty sky. There is a sadness which is quite odd if you consider the subject matter. We felt the world needed a picture of that subject.

Gilbert: We did other ones.

George: But this is the saddest one.

1995

48 TEARS 1987 | 241 x 201 cm (95 x 97 in)

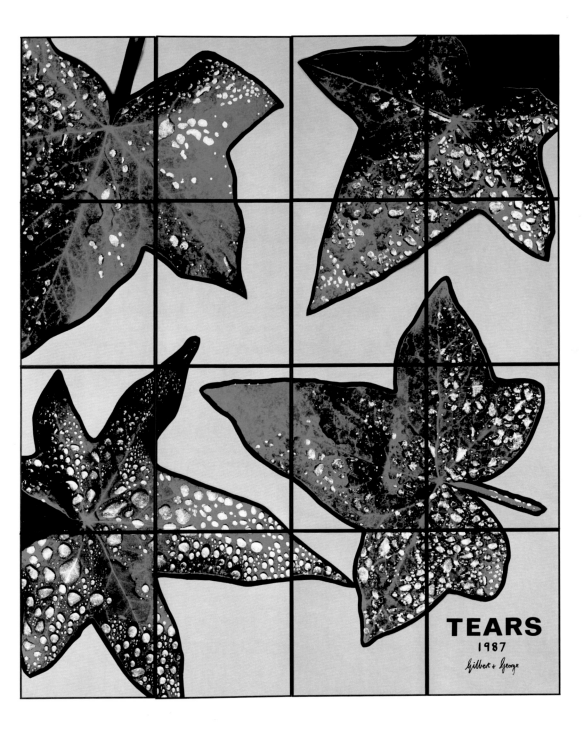

TEARS

1987

Gilbert & George

We believe that art is there for meaning, and that artists who make what we call art-art, just to add to this funny, quirky history of technique and isms, are very wrong. They're missing the whole point of the function of art.
1986

49 PAINS 1988 | 181 x 151 cm (71 x 59 in)

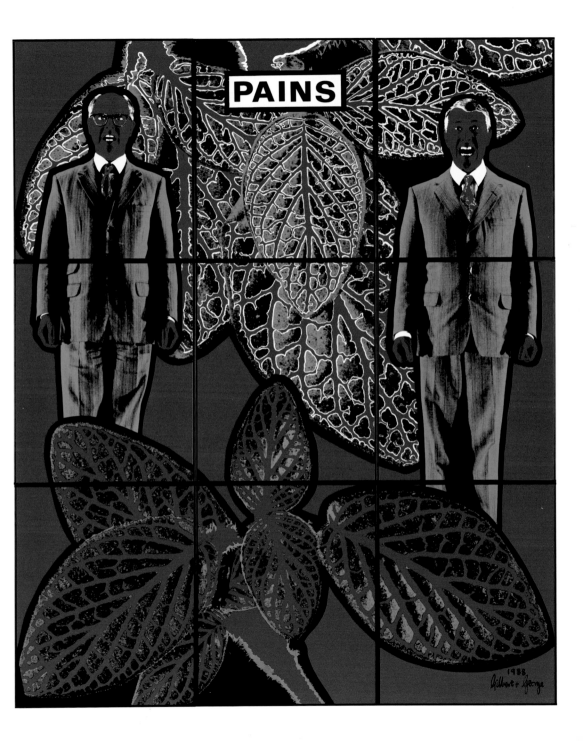

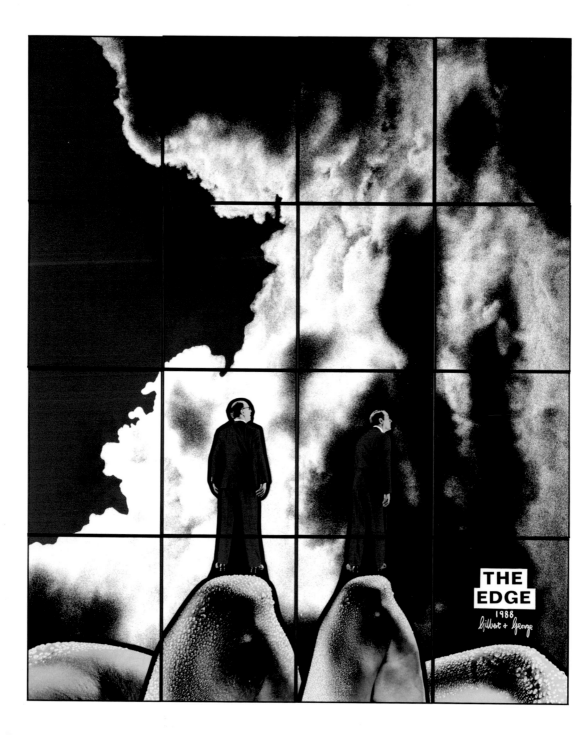

PRIVATE & OCCULT

Throughout Gilbert & George's art, the ghost of William Blake keeps hovering, as if reincarnated in the contemporary world. This is true even of their language. Like Blake, they fuse word and image, repeating their titles within their pictures and at times, as in *Dusty Corners* and *Bad Thoughts* (1975, figs 12, 15), they even inscribe the titles across the pictures, like book jackets on a personal diary. Their insistence on the simplest Anglo-Saxon words also echoes Blake's diction. Their rock-bottom titles – *Death*, *Hope*, *Life*, *Fear* (1984, figs 40–3) (not to mention their repertory of less churchly four-letter words) – revive the sturdy, often monosyllabic simplicity of Blake's vocabulary and rhymes. Moreover, Blake's exalted ambitions to create a new kind of religious imagery, in which glimpses of the great beyond may be invoked by wild shifts of scale and fantastic inventions (extraterrestrial heads, armies of angels, cosmic vistas, naked souls, figures wed to flowers) may all find counterparts in Gilbert & George's art. But most of all, it is the overriding symmetry of structure in their pictures that bears analogy with the art of the great British founder of a personal religious universe.

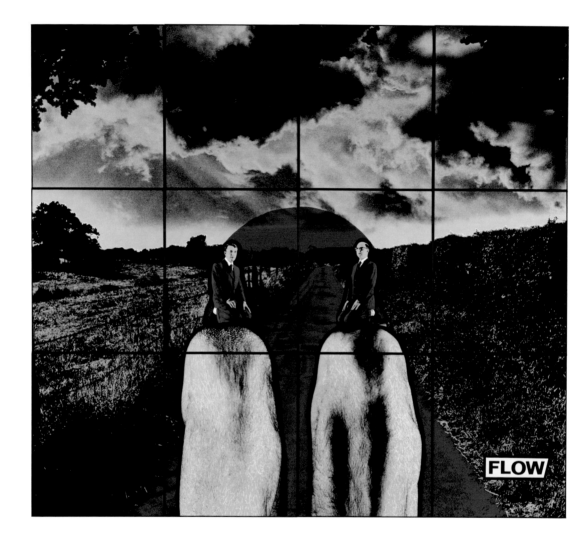

51 FLOW 1988 | 253 x 284 cm (100 x 112 in)

The titles are a key part of the pieces. They are like a key – it's the nearest word – to aim the person in the direction of where we want them. Because we say that inside every person there are only three forces: the brain or the head, the soul which we think is separate, and the sex. And one's always working between those three elements, and we're speaking to those three elements.

1985

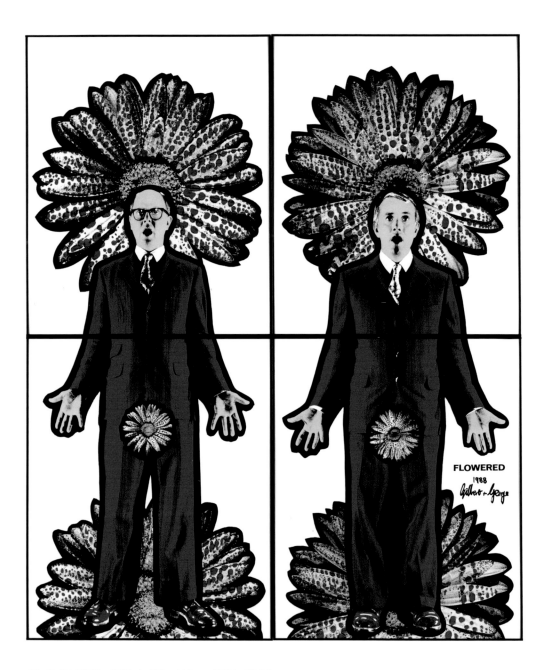

FLOWERED
1988
Gilbert & George

52 FLOWERED 1988 | 169 x 142 cm (66½ x 56 in)

We wanted to do art to be embarrassed. Art that embarrasses ourselves. I think we still do that. We are very embarrassed sometimes at what we are doing, and that's a good feeling. When it hurts, then it's true for us.

1997

Symmetry, of course, was almost inevitable for two artists who functioned in life and in art as an equal and indissoluble pair. Their most famous living piece, *The Singing Sculpture* (fig. 3), first presented on 20 January 1969 at St Martin's School of Art, immediately established an invisible central axis that would forever unite the artists. With their movements severely restricted by the rectangular tabletop on which they repeated their act, they became twinned for eternity, in the tradition of such venerable entertainers as Flanagan and Allen, Laurel and Hardy, Abbott and Costello, and Flanders and Swann, a yoked bondage they later resumed in another living piece, *The Red Sculpture* (1975, fig. 16), that, with its seemingly endless repetitions, once again evoked the endurance of factory workers or Christian martyrs. In the pictures of the 1970s, their rigidly paired presence can regiment the unruly environments of landscape or drunkenness. By the mid-70s, such works as *Dusty Corners*, *Bloody Life* (1975, fig. 14) and *Bad Thoughts No. 9* take on an absolutely heraldic format in which the artists become the Jacks and Kings of new sets of playing cards. It is this kind of symmetrical patterning, together with the signature grid structure of framed, rectangular modules that looms larger and larger in their art. Moreover, their favourite spatial

orientation – figures immobilized in frontal or profile postures – underlines their ambition to create permanent, confrontational emblems of their private cosmos. By the 1980s, this format, especially when stretched to their works' ever-welling dimensions, produces an awesome effect, numbing us with, in the words of Blake, a 'fearful symmetry' which can make the initiate believe that even the artists' most fantastic imagery can disclose permanent revelations. With this hypnotically fixed armature of a central axis dominating a grid pattern, Gilbert & George can soar with greater ease from heaven to earth, from urban fact to celestial fiction. In *Stepping* (1983, fig. 34), the daily experience of crossing one's private threshold onto the public sidewalk is transformed into an erotic adventure of eternal pursuit. Floating above the head-on view of a London street's converging perspective, a huge, luridly coloured orchid, charged, like all the artists' other flowers, with sexual metaphors, hovers both near and far, supported in erotic imagination by the almost Gothic arches of lush green foliage. In *Drained* (1983, fig. 36), the mundane fact of a drain noticed on the pavement is meta-morphosed into something akin to a Last Judgment, as this metal gate threatens to suck into hellish darkness the ghoulish heads of a modern Dante and Virgil who would

venture into London's River Styx. Without the artists' insistent, heraldic symmetry, such nightmares could never convince us. As if by magic, a sewer drain has been raised from the pavement to become an unholy icon whose magnetic, centralized power can forever hold the artists in its sway. But the climax of this Blakean series of visions is the awesome quartet *Death, Hope, Life, Fear*, four altarpieces, two vertical and two horizontal, that cast the artists in the role of ministers of their private religion, offering themselves, arms either stiffly at their sides or raised in oracular mystery, as the vehicles of redemption or salvation to a congregation of male youths eager to convert to a new faith. We can see and hear their bodies and spirits echoing into the infinites of supernatural space, taking us to the fearful gates of heaven and hell that, two centuries earlier, William Blake had also seen and depicted.

Even in their wildest adventures through a universe of their own imagination, Gilbert & George can impose their shared fantasies on the world at large. In *Blood, Tears, Spunk, Piss* (1996, fig. 60), they have constructed a new version of the Book of Genesis. Here, the microscopic magnifications of the biological stuff we are all made of – bluntly identified in the title – becomes an engulfing tapestry of organic

decoration, a new Garden of Eden marked both by scientific fact and religious dreams that would take us and the artists back to our mythical origins. Again, it is the fearful symmetry of the construction that makes it possible to believe in this world. In the exact centre, the four fluids of the title – bodily effusions they had often depicted on a smaller scale in such works as *Coming* (1975) or *Bleeding* (1988, fig. 53) – are joined as a central spine for an enveloping image that would capture life's biological and emotional core. Mirrored at the extreme left and right, the artists are twice paired in this enchanted, but terrifying wilderness, primal beings as naked and as vulnerable as Adam and Eve. They are, if anything, even more vulnerable in *Spunkland* (1997, fig. 62). Here, they tremble in their nakedness on the brink of an infinite ocean of spermatic fluid, dominated by its own celestial orb, a vision of primordial sexual forces that, for all its startling newness, had already been evoked in the 1890s by Edvard Munch, who depicted symbols of lust and consummation surrounded by Darwinian decorative margins pulsating with the sperm cells that determine all our fates.

Like Blake's invented cosmos, Gilbert & George's universe may seem so private and occult as to defy rational interpretation; but like Blake, Gilbert & George also hoped to reach

a vast public that extended far beyond the limits of educated art lovers. Against all odds, Blake and Gilbert & George have succeeded in doing this. Despite their cryptic aura, the sheer, confrontational power of their fantasies, presented as emblems of authoritative clarity, continues to speak to large popular audiences all over our planet. After all, Gilbert & George's exhibition history includes not only familiar venues for contemporary art such as London, Paris and New York, but also Moscow, Beijing and Shanghai.

Our art is as English as England is anyway global. If you want to live in the world this is the place. It's the only place where you have a total grasp of the whole world. Whatever is happening in every country you can feel it in London. Every single building, every single person, every scratch on a tree, is global because it is one of the most modern places in the world.

1981

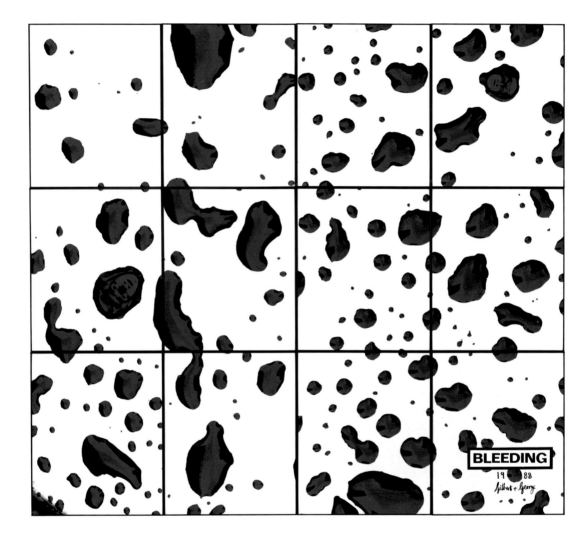

The artwork contains the text: BLEEDING 19 88 Gilbert + George

BLEEDING 1988 | 226 x 254 cm (89½ x 100 in)

Then we had the AIDS disaster – the falling of death that became involved in all the blood of all our friends. All our friends were dying and so we saw all this end of life in front of us, every single day, and I think that had a big effect on us.

1997

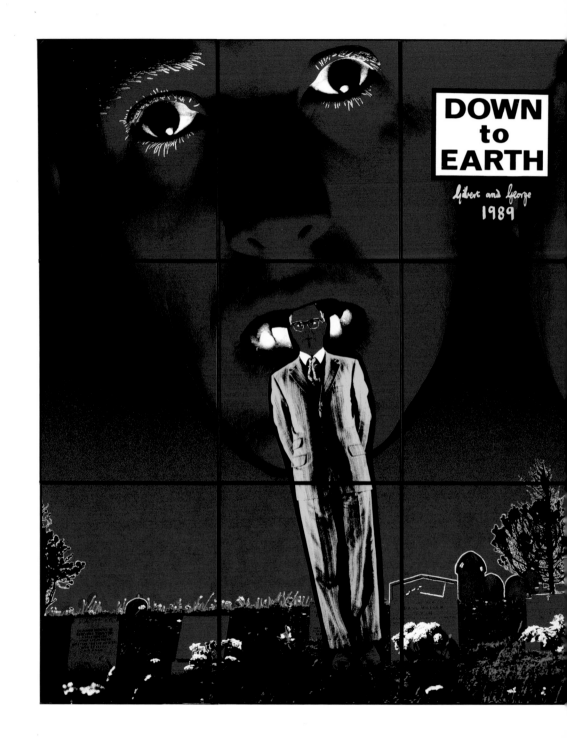

DOWN
to
EARTH

Gilbert and George
1989

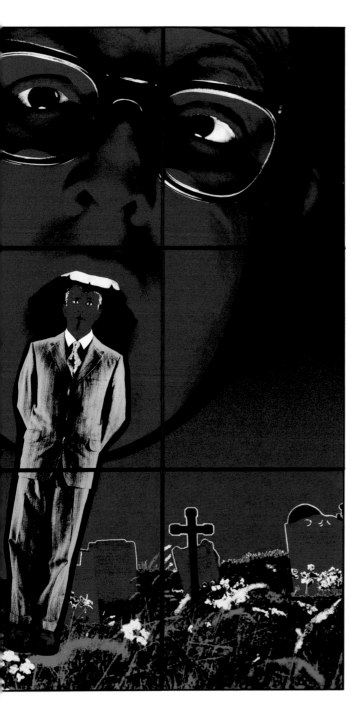

54 DOWN TO EARTH 1989
226 x 317 cm (88 x 124⅞ in)

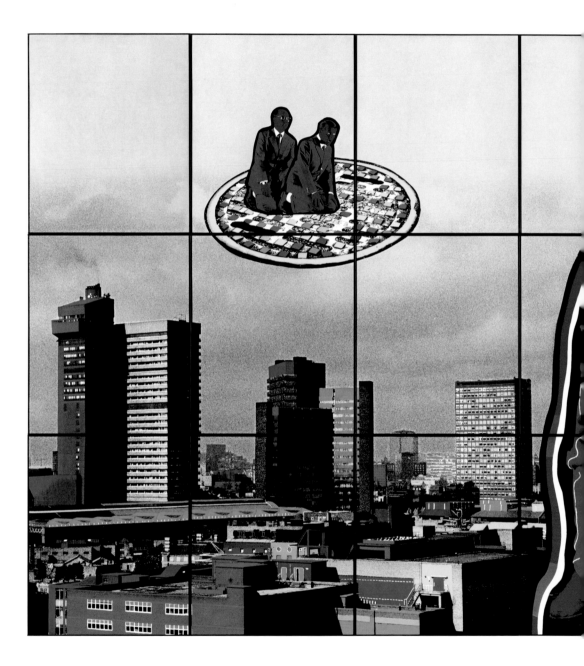

55 HERE AND THERE 1989 | 253 x 497 cm (100 x 195⅝ in)

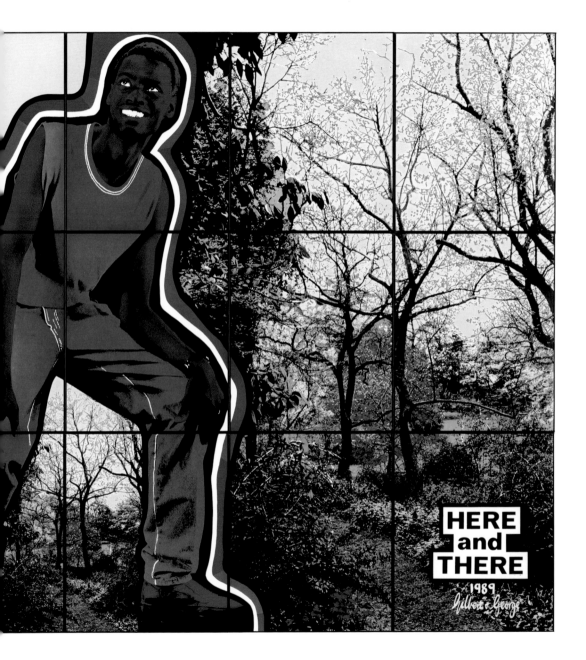

HERE
and
THERE
1989
Gilbert & George

125

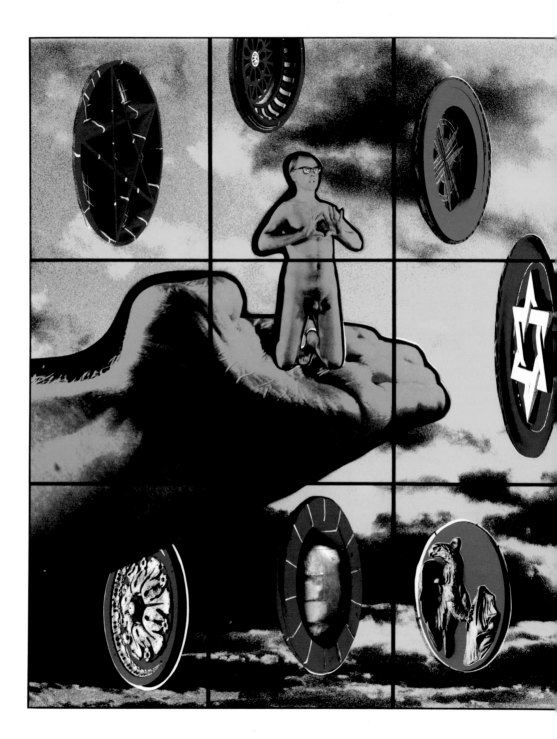

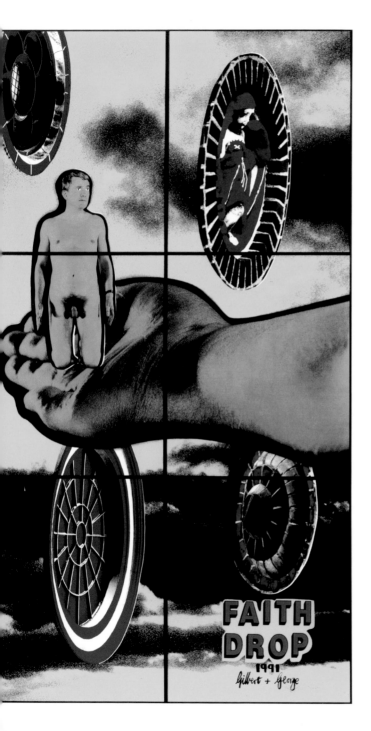

56 FAITH DROP 1991
253 x 355 cm (100 x 139¾ in)

George: We think we are very gentle in our approach to the viewer, really. We know how fragile we are, so we can imagine that the viewer is equally fragile.... One of the main subjects under discussion is the human reality that there is no nakedness without a viewer: we are not naked when we are alone.... You don't need to have your eyes open to feel naked in front of another person. The other person is looking. Gilbert: You can concentrate on the inner feelings if you close your eyes.... In some way humanity is based on hiding everything. You have clothes, you have hats, you have – what are they called – gloves. You are hiding everything. But we open ourselves up and I think this is very difficult because the vulnerability of human beings is so difficult.
1997

SHUT
1992
Gilbert + George

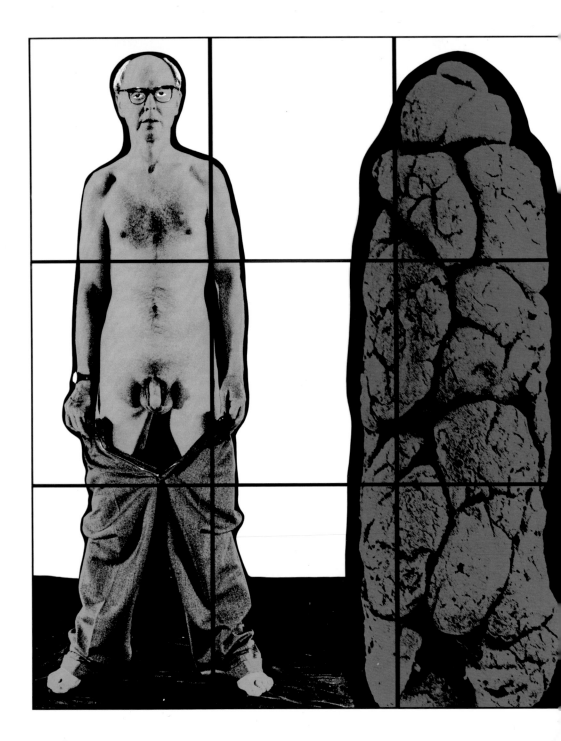

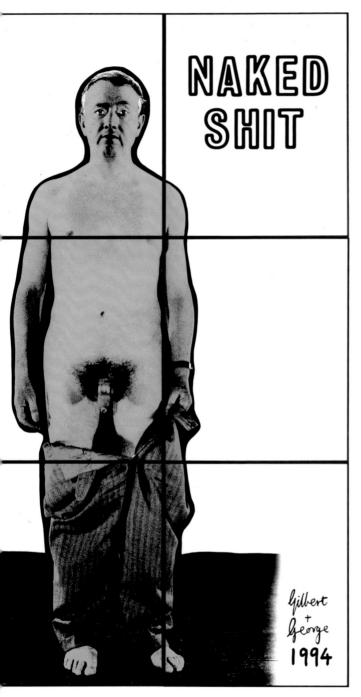

NAKED
SHIT

Gilbert
+
George
1994

58 NAKED SHIT 1994
253 x 355 cm (100 x 139¾ in)

It's very interesting that people are alarmed, as probably we are as well, by the combination of naked and shit. It's interesting that that should be alarming, because of the fact of life is that you have to be at least partly naked in order to shit. You cannot shit with your clothes on. So it's very natural, the combination of those two subjects.

1995

Shit and faith put together, like in *Shit Faith* [1982] or in the big shit cross in the Naked Shit Pictures, should be great unifying themes. All people, wherever they live, have some involvement with shit. All people have some faith or attitude towards faith. Wherever you live, whatever your age, whatever your education, those two things are common elements.
1995

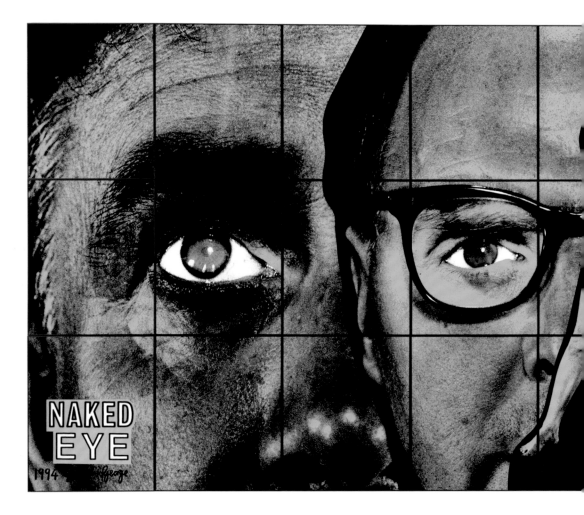

59 NAKED EYE 1994 | 253 x 639 cm (100 x 251½ in)

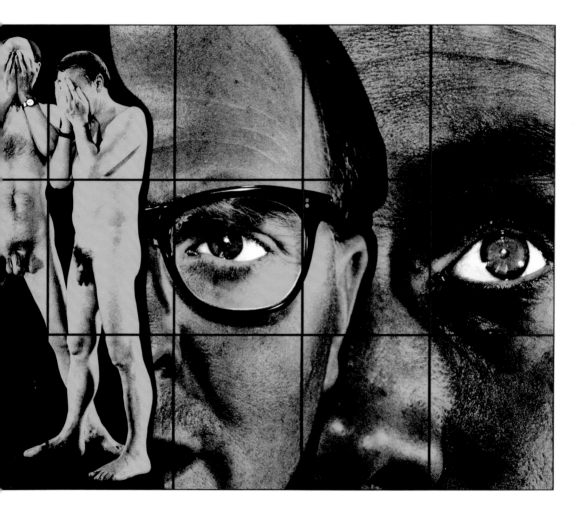

135

Gilbert: We don't believe that there is anything wrong in doing pieces to do with shit because shit is part of us. Or to do with nakedness – especially of men. It's strange: a naked lady is wonderful; two naked ladies, very interesting; but two men naked …

George: One man naked is a male study; more than one, well … that's quite serious – two men naked are more naked than one.

1995

For us, being naked in front of the public, we are trying to make ourselves vulnerable in front of the viewer. That is very important because art is based on making ourselves more vulnerable and opening up what is inside us. We never look at what is outside the world; we always look inside the world, and this kind of picture [*Naked Eye*, 1994] in some way is showing the world what we actually are inside. It's all the difficulties, all our problems and all our complexities.

1997

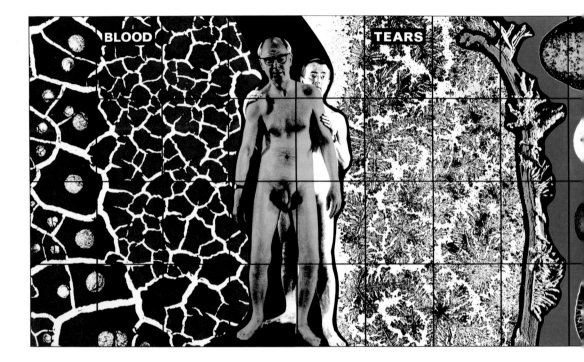

60 BLOOD, TEARS, SPUNK, PISS 1996 | 338 x 1207 cm (133 x 475 in)

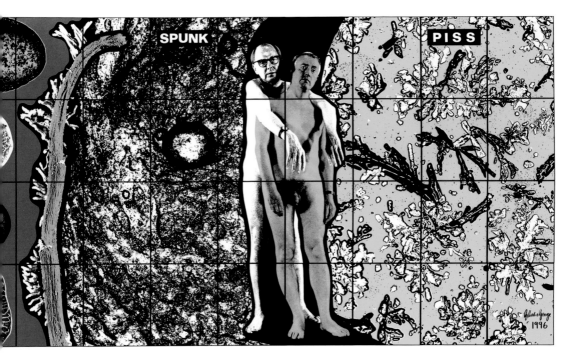

61
SPAT ON 1996
190 x 302 cm
(75 x 119 in)

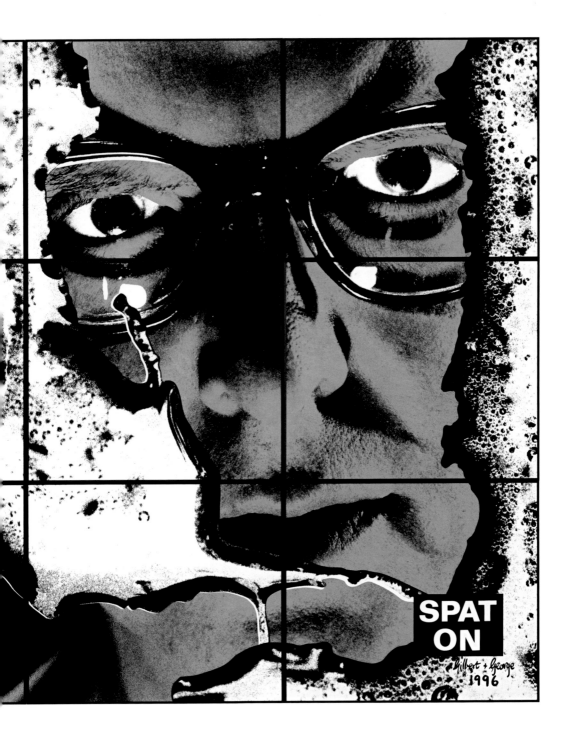

SPAT
ON

Gilbert + George
1996

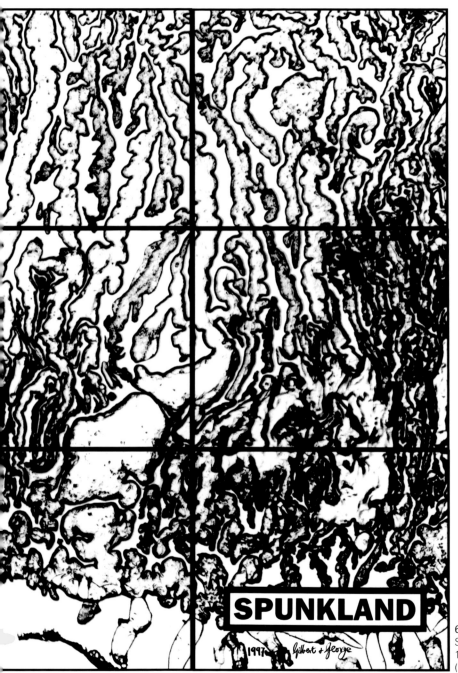

SPUNKLAND

62
SPUNKLAND 1997
190 x 302 cm
(74⅞ x 118⅞ in)

George: If a picture doesn't say 'fuck you', it's no good anyway. It has to defy the viewer first of all, then it can go on to say other things, of course. I think that's the basic premise. The picture is better than the viewer, first. We hate the idea of superior people going through the galleries, admiring this and admiring that.
Gilbert: Ignoring it.
George: That's anti-culture, anti-life totally. They must not feel as though they know something – then it's all wrecked. If someone says, 'How marvellous, beautiful. It's so much this or so much that', it's no good. You want them to stand in front of the picture and say, 'What the shitting hell does this mean to me?'
1982

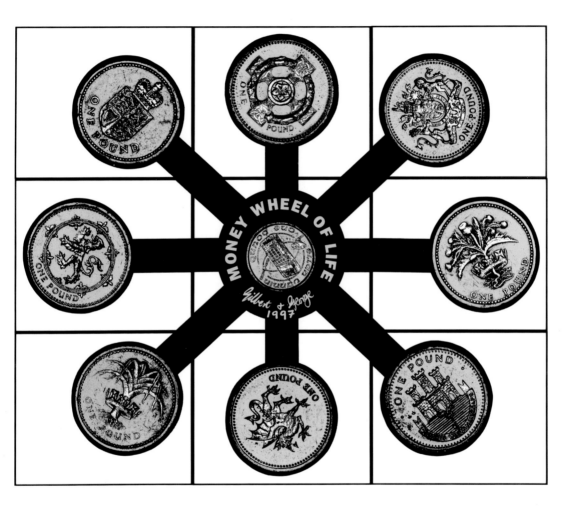

63 MONEY WHEEL OF LIFE 1997 | 190 x 226 cm (74⅞ x 88⅛ in)

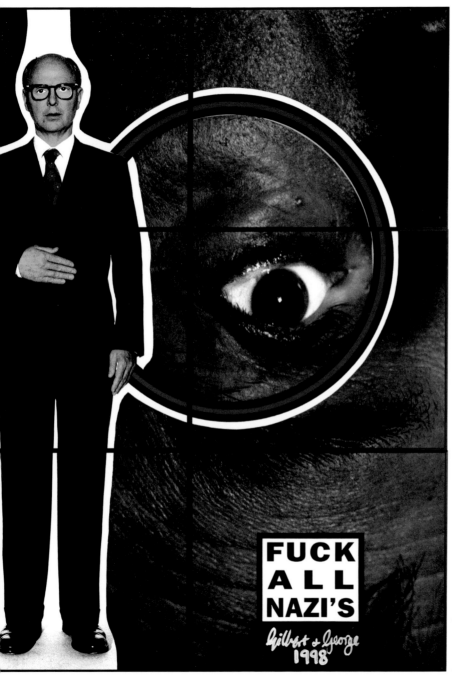

64
FUCK ALL NAZI'S
1998
190 x 302 cm
(74⅞ x 118⅞ in)

THEN & NOW

The hermetic world of art and life created by Gilbert & George may at first seem untethered to space-time coordinates on earth, but just as Blake's visions, however unique, can be related to the art world of his time, so too is Gilbert & George's bell-jar universe in constant contact with what their more earthbound contemporaries are doing. After all, they show their art at the same galleries and museums that welcome artists of every stripe; and though they appear to live and work in grand isolation, their achievements also belong fully to the story of late-twentieth-century art. No matter where we look, they play a major role in the innovations of their generation.

There is, for one, their seamless fusion of what, before the 1960s, was thought of as the very different arts of photography and painting. It is typical of the erasure of these boundaries that, although Gilbert & George's work is by and large created through the medium of photography, it is experienced and classified in a blurrier domain that used to be exclusive to paint on canvas. When they were included, like Andy Warhol, in the Royal Academy's sesquicentennial exhibition, 'The Art of Photography 1839 to 1989', it came

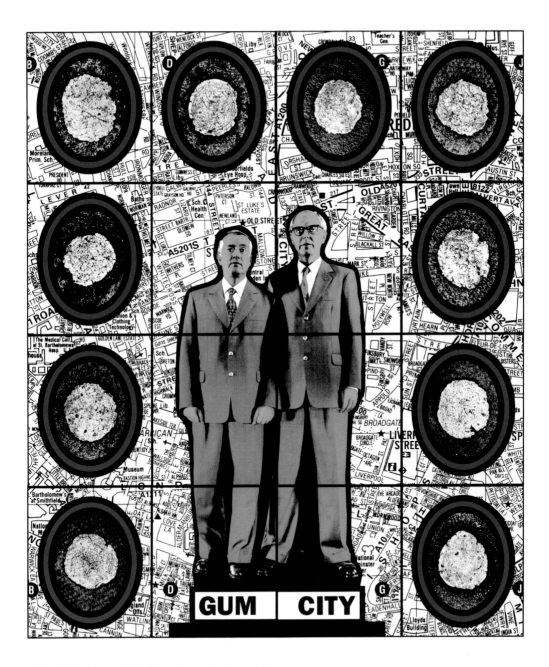

GUM CITY

65 GUM CITY 1998 | 338 x 284 cm (133 x 111¾ in)

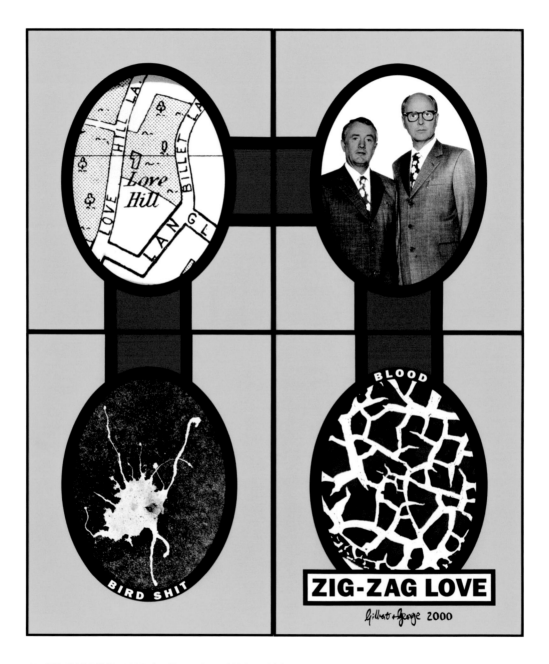

Text within the artwork:
- Love Hill
- LOVE HILL LA.
- BILLET LA.
- LANGL
- BLOOD
- BIRD SHIT
- ZIG–ZAG LOVE
- *Gilbert + George* 2000

as something of a surprise to realize that they could also fall into the same category that included Eugène Atget, Robert Frank and Diane Arbus. But in fact, the history of recent art has constantly ignored the conventional distinctions between photography and more exalted handmade media. In the work of Robert Rauschenberg and Andy Warhol, silkscreening has made it possible to absorb photographic images into the very weave of canvas and paint, mocking old-fashioned distinctions between high art and low art; and by now, the fact that the huge photographic heads by Chuck Close are painted by hand, whereas the equally huge heads by Thomas Ruff are actual photographs, seems insignificant. They can be experienced in almost the same way, dropping moribund classifications by medium. If Sol LeWitt chooses to expand his fascination with abstract geometry by photographing a series of sewer covers (also one of Gilbert & George's motifs), he has not suddenly switched from being a sculptor or draughtsman to being a photographer, but is simply using photography as a means to make his point.

Then there is the reign of the grid, vital to the skeleton of late-twentieth-century art. From the 1970s revival of Eadweard Muybridge's checkerboard patterns of sequential

motion photographs to the underlying structure of so many works by Jasper Johns, Andy Warhol, Carl Andre or Chuck Close, it is possible to see that Gilbert & George are marching to a similar regimental beat. Even their geometric fantasies on the theme of hustlers' ads, like *I Am* (2001, fig. 70), can be seen in this context, mirroring, but now below the belt, the vogue in the 1970s and 1980s for endless grids of printed or written words, as in the work of On Kawara or Hanne Darboven. The human counterpart to this obsessive geometric order is also a territory Gilbert & George share with many of their contemporaries. Their own body images, so central to their work, belong fully to this international attack of the humanoids. *The Singing Sculpture* and *The Red Sculpture* were landmarks in the history of performance art in which the artists as living, three-dimensional facts were fully absorbed into their work (just as in the performances of Scott Burton, Vito Acconci, Joseph Beuys and Chris Burden). And their stiff, iconic self-portraits that, like aliens, watch over their art, also belong to this recent mutation of the human species, a race of inorganic creatures from a world of factories and science fiction. Their eerie kin can be found everywhere, whether in the clonelike figures of Duane Hanson and Ron Mueck, the

prosthetic humanoids of Matthew Barney's films, or the living mannequins who stand immobilized in Vanessa Beecroft's performance pieces.

Yet for all these connections, Gilbert & George have a habit of floating away to another, very different planet of their own making. It may be comforting to realize that, for all their uniqueness, they maintain multiple contacts with the art world on planet Earth, but the greater astonishment is that they have created an enormous private cosmos and live securely within it. When we visit them there, we can find everything from the office buildings of London to human blood cells, from daily diary entries to visions of the afterlife. They give us new ways of seeing not only the world they live in, but all of our mortal bodies and souls, afloat between sex and death, hope and despair.

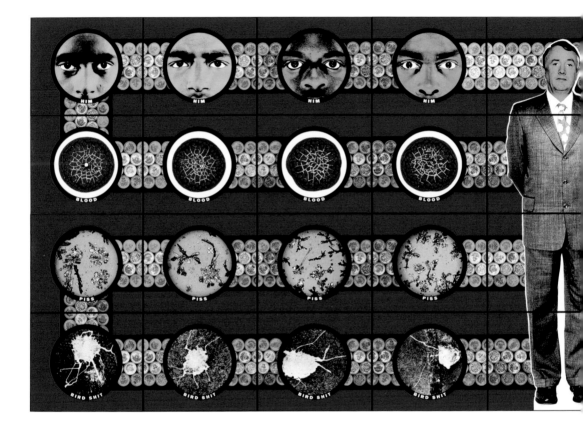

67 ZIG–ZAG KISMET 2000 | 284 x 845 cm (111⅝ x 333 in)

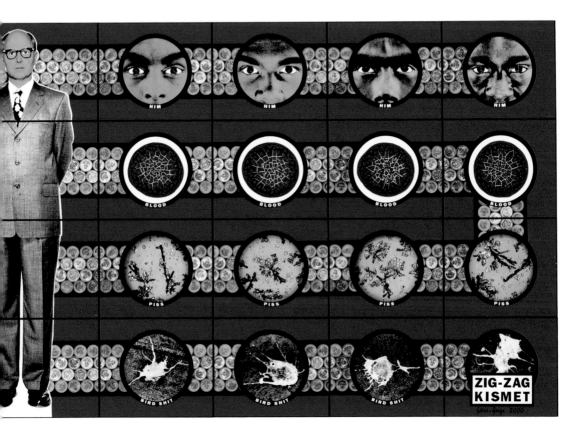

It is important to us to publish our art in books and catalogues, so as many people as possible are able to see it, but we also want them to see the real pieces. We like it very much when the pictures take over. When they're bigger than the viewer. You go to a museum to look at a picture, but we like it when the picture looks at you.

1986

68 GEOGRAPHY 2001 | 355 x 253 cm (139¾ x 100 in)

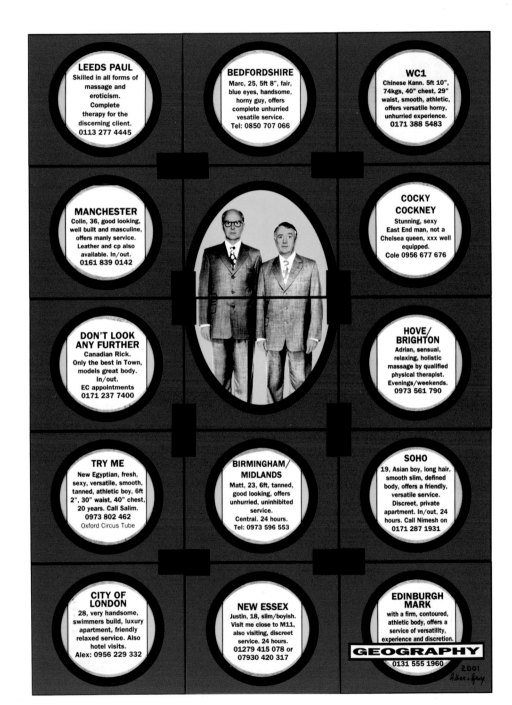

PICCADILLY CIRCUS

A well equipped and truly gorgeous gymnast, 24 yo, washboard abs, smooth, tanned and a real 13 stone muscular body. Call Alex for more, friendly info.
0956 419 404

OXFORD CIRCUS

27, good looking, 5ft 11", 40" chest, 28" waist, straight looking/acting, extra VW equipped, great behind, offers passive type service. In/out calls and hotel visits. 24 hours. **Steve: 0958 33 77 81** If I'm now what I say, you don't pay.

LEICESTER SQUARE

The best, well equipped 24 yo, straight acting, and a genuine, defined 13 stone, muscular physique, smooth, tanned and always hard.
Call me 24 hrs. Chris
0171 434 3599

WEST END

2001

Gilbert and George

If you are submerged in normal life, then your view will be normal. So we have to keep separate from normal life in order to be able to say something that is not known. People come to art for something that they don't understand, that's not in their life already.

1985

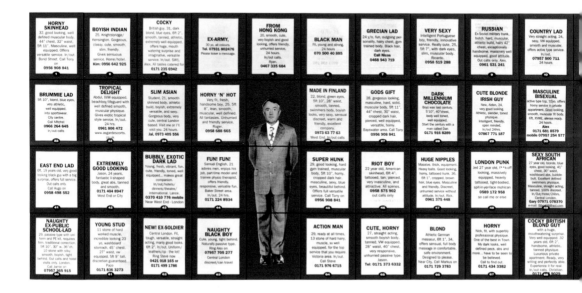

HORNY SKINHEAD
32, good looking, well defined muscular body. 44" chest, 32" waist. 5ft 11". Masculine, well equipped. Offers versatile service. In/out. Bond Street. Call Tony on
0956 908 841

BOYISH INDIAN
25. Knightsbridge/ Kensington. Gorgeous, classy, cute, smooth, slim, friendly. Gives sensuous service. City centre.
Kim: 0956 642 925

COCKY
British guy, 31, dark blond, blue eyes, 6ft 2", smooth, tanned, athletic, extremely well equipped. offers huge, mouth watering surprise and imaginative, versatile service. In/out. SW1.
Tel. 07931 802476
Please leave a message.

EX-ARMY,
30 yo, all colours.
0171 235 6942

FROM HONG KONG
20, smooth, cute, very boyish and good looking, offers friendly, unhurried service, 24 hours. In/out calls.
Ryan.
0467 335 684

BLACK MAN
Fit, young and strong, 24 hours
070 500 40 885

GRECIAN LAD
24 y/o, fun, outgoing personality, hairy chest, gym trained body. Black hair, dark eyes.
Call Nicos
0468 943 719

VERY SEXY
Intelligent Portuguese boy, friendly, innovative service. Really cute, 25, 5ft 7", with dark eyes, slim, muscular body. Ricardo.
0958 519 288

RUSSIAN
Ex-Soviet military hunk, butch, hard, muscular, athletic build, hairy 42" chest, exceptionally handsome, massively well equipped, good attitude. Out calls only. Alex.
0961 531 241

COUNTRY LAD
Very straight acting, 24, sexy, VW equipped, smooth and muscular, offers active type service. In/out.
07957 500 711
24 hours

BRUMMIE LAD
5ft 10", blond, blue eyes, very athletic, well equipped, into sportswear. City centre.
Call Mitchel
0966 264 645
In/out calls

TROPICAL DELIGHT
Abdul, XVW equipped, beachboy/lifeguard with well defined smooth, muscular physique. Gives exotic tropical style service. In/out. 24 hrs.
0961 806 472
www.asgardescorts.

SLIM ASIAN
Student, 21, smooth skinned body, athletic build, boyish, extremely versatile, and sexy. Gorgeous body, very cute, central London based. Visit me or I'll visit you. 24 hours.
Jal, 0973 405 556

HORNY 'N' HOT
Very fit, fresh, handsome boy, 25, 5ft 8", lean, smooth, muscular, well defined. All fantasies. Unhurried and friendly service. Roger.
0958 688 665

MADE IN FINLAND
22, blond, green eyes, 5ft 10", 28" waist, smooth, tanned, swimmers body, boyish looks, very sexy, sensual discreet, warm and friendly, excellent company.
0973 63 77 63
West End. In/out calls

GODS GIFT
28, gorgeous looking, masculine, hard, solid, muscular body, 5ft 11", 44" chest, 32" waist, cropped dark hair, pierced, well equipped, versatile, horny. Bayswater area. Call Tony
0956 908 841

DARK MILLENNIUM CHOCOLATE
Brad was last century. 5'10", 40"chest, body well toned, well equipped. Start the century with a man called Dan.
0171 916 8289

CUTE BLONDE IRISH GUY
Very good looking Athletic, slender, toned physique. Intelligent, friendly, open minded. In/out 24hrs.
07867 771 187

MASCULINE BISEXUAL
active type too, 33yo, offers horny service in private appartment. Good looking, smooth, muscular fit body. 6ft, XVWE, always ready. 24 hours.
Alex
0171 681 8579
mobile 07957 254 577

EAST END LAD
6ft, 19 years old, very good looking black gus with a big surprise, offers full service. Out calls only.
Call Hugo on
0958 498 552

EXTREMELY GOOD LOOKING
Jason, 24 years, fantastic V-shaped body, great abs, tanned and smooth.
0171 404 8947
West End or City

BUBBLY, EXOTIC DARK LAD
Young, fresh, vibrant, fun, cute, friendly, toned, well equipped... makes great companion. In/out/hotels/ dinners/theatre/ international. Lance.
0370 410 776 mobile
Near West End - London

FUN! FUN!
Samuel English, 21 adores men, enjoys his job, part-time model and trainee physio therapist, offers friendly, responsive, versatile fun. Baker Street area. In/out, 24 hrs.
0171 224 8934

SUPER HUNK
29, good looking, hard gym trained, muscular body, 5ft 10", horny, cropped dark hair, masculine, sexy, blue eyes, beautiful behind. Offers full versatile service. Call Tony on
0956 908 841

RIOT BOY
22 year old, American skinhead, 6ft 4", tattooed, tan, pierced, very masculine, and attractive. All scenes.
0958 575 902
out calls only

HUGE NIPPLES
Massive, thick, equipped. Heavy balls. Good looking, horny, tattooed hunk. 36, 6ft 1", cropped, brown hair, blue eyes. Masculine and friendly. Discreet, unhurried service without attitude. In/out. Rick.
0961 375 448

LONDON PUNK
Jed 27 year old, f**k-off looking, massively equipped, heavily tattooed, tight-bodied, spit-in-yer-face mohican.
0589 172 958
so call me or else

SEXY SOUTH AFRICAN
27 year old, blonde, blue eyes, good looking, 41" chest, 30" waist, washboard abs, bubble-butt. Excellent defined swimmers physique. Masculine, straight acting, tanned, 100% discreet. In/Out/Hotel/24hrs. Central London.
Gary 07971 078370
e-mail ...@...

NAUGHTY EX-PUBLIC SCHOOL-LAD
29, passive type with uniform and PE kit, requires firm, traditional correction. 5ft 10". 30" w, 36"ch. 13 stone with silky smooth, boyish, tight behind. Out calls and hotel visits only. London.
Call Jamie on
07957 365 915

YOUNG STUD
11 stone of hard worked muscle, incredible looking 23 yo, washboard stomach, 45" chest, 27" waist, vw equipped. 5ft 9" tall, discretion guaranteed. Paco
0171 836 3273

NEW! EX-SOLDIER
Central London. Fit, tough, versatile, straight acting, manly good looks. 6ft 2". In/out. Uniform/ leathers/cp - the lot! Ring Steve now.
0421 018 165 or
0171 499 1786

NAUGHTY BLACK BOY
Cute, young, tight behind. Naturally passive type. Ring Alex on
07957 705 277
Central London
discreet/can travel

ACTION MAN
29, ready at all times. 13 stone of hard hairy muscle, xx well equipped, for the top service that you require. Victoria area. In/out.
Call Steve
0171 976 6715

CUTE, HORNY
27, straight acting, smooth boyish body, tanned, VW equipped. 28" waist, 40" chest. very responsive, unhurried passive type.
Tel: 0171 373 6332

BLOND
Athletic German masseur, 6ft 1", 34. offers sensual, full body massage in comfortable, safe environment. Designed to please. Near City, Call Markus on
0171 729 3783

HORNY
Nick, fit, with superbly professional physique. One of the best in Town. My dark looks, well defined pecs, abs and more... have to be seen to be believed.
Call to find out.
0171 434 3382

COCKY BRITISH BLOND GUY
with a huge, mouthwatering surprise. Very well equipped. 32 years old. 6ft 2", handsome, athletic, tanned physique. Luxurious private apartment. Ready, very willing and perfectly able. Experience it for real. In/out calls. Christian.
0171 ... 9025

161

71 JESUS SAID 2001 | 226 x 254 cm (88 x 100 in)

George: We don't argue, but even if we did we wouldn't tell. We believe that the world is one big enormous argument, and we think we at least should try to keep away from that. Gilbert: If we started to argue, everything would fall apart very fast. Because it is based on accepting the two, the view of two people together. If not, you are finished immediately. It wouldn't work. It wouldn't work.
1997

72
ANIMOSITY 2001
190 x 302 cm
(74⅘ x 119 in)

GILBERT & GEORGE: A CHRONOLOGY

Gilbert
Born Dolomites, Italy, 1943

George
Born Devon, England, 1942

Studied
Wolkinstein School of Art
Hallein School of Art Centre
Munich Academy of Art

Studied
Dartington Adult Education
Dartington Hall College of Art
Oxford School of Art

Met and studied
St Martin's School of Art, London, 1967

Gallery Exhibitions
1968
'Three Works/Three Works'. Frank's Sandwich Bar, London
'Snow Show'. St Martin's School of Art, London
'Bacon 32'. Allied Services, London
'Christmas Show'. Robert Fraser Gallery, London

1969
'Anniversary'. Frank's Sandwich Bar, London
'Shit and Cunt'. Robert Fraser Gallery, London

1970
'George by Gilbert & Gilbert by George'. Fournier Street, London
'The Pencil on Paper Descriptive Works'. Konrad Fischer Gallery, London
'Art Notes and Thoughts'. Art & Project, Amsterdam
'Frozen into the Nature For Your Art'. Françoise Lambert Gallery, Milan
'The Pencil on Paper Descriptive Works'. Skulima Gallery, Berlin
'Frozen into the Nature For You Art'. Heiner Friedrich Gallery, Cologne
'To Be With Art Is All We Ask'. Nigel Greenwood Gallery, London

1971
'There Were Two Young Men'. Sperone Gallery, Turin
'The General Jungle'. Sonnabend Gallery, New York
'The Ten Speeches'. Nigel Greenwood Gallery, London
'New Photo-Pieces'. Art & Project, Amsterdam

1972
'New Photo-Pieces'. Konrad Fischer Gallery, Düsseldorf
'Three Sculptures on Video Tape'. Gerry Schum Video Gallery, London
'The Bar'. Anthony d'Offay Gallery, London
'The Evening Before the Morning After'. Nigel Greenwood Gallery, London
'It Takes A Boy To Understand A Boy's Point of View'. Situation Gallery, London
'New Sculpture'. Sperone Gallery, Rome

1973
'Any Port in a Storm'. Sonnabend Gallery, Paris
'Reclining Drunk'. Nigel Greenwood Gallery, London
'Modern Rubbish'. Sonnabend Gallery, Paris
'New Decorative Works'. Sperone Gallery, Turin

1974
'Drinking Sculptures'. Art & Project/Mtl Gallery, Antwerp
'Human Bondage'. Konrad Fischer Gallery, Düsseldorf

'Dark Shadow'. Art & Project, Amsterdam
'Dark Shadow'. Nigel Greenwood Gallery, London
'Cherry Blossom'. Sperone Gallery, Rome

1975
'Bloody Life'. Sonnabend Gallery, Paris
'Bloody Life'. Sonnabend Gallery, Geneva
'Bloody Life'. Lucio Amelio Gallery, Naples
'Post-Card Sculptures'. Sperone Westwater Fischer, Naples
'Bad Thoughts'. Gallery Spillemaekers, Brussels
'Dusty Corners'. Art Agency, Tokyo

1976
'Dead Boards'. Sonnabend Gallery, New York
'Mental'. Robert Self Gallery, London
'Mental'. Robert Self Gallery, Newcastle
'Red Morning'. Sperone Fischer Gallery, Berlin

1977
'Dirty Words Pictures'. Art & Project, Amsterdam
'Dirty Words Pictures'. Konrad Fischer Gallery, Düsseldorf

1978
'Photo-Pieces'. Dartington Hall Gallery, Dartington Hall
'New Photo-Pieces'. Sonnabend Gallery, New York
'New Photo-Pieces'. Art Agency, Tokyo

1980
'Post-Card Sculptures'. Art & Project, Amsterdam
'Post-Card Sculptures'. Konrad Fischer Gallery, Düsseldorf
'New Photo-Pieces'. Karen & Jean Bernier Gallery, Athens
'New Photo-Pieces'. Sonnabend Gallery, New York
'Modern Fears'. Anthony d'Offay Gallery, London
'Photo-Pieces 1980–1981'. Chantel Crousel Gallery, Paris

1982
'Crusade'. Anthony d'Offay Gallery, London

1983
'Modern Faith'. Sonnabend Gallery, New York
'Photo-Pieces 1980–1982'. David Bellman Gallery, Toronto
'New Works'. Crousel-Hussenot Gallery, Paris

1984
'The Believing World'. Anthony d'Offay Gallery, London
'Hands Up'. Gallery Schellmann & Kluser, Munich
'Lives'. Gallery Pieroni, Rome

1985
'New Moral Works'. Sonnabend Gallery, New York

1987
'New Pictures'. Anthony d'Offay Gallery, London
'New Pictures'. Sonnabend Gallery, New York

1988
'The 1988 Pictures'. Ascan Crone Gallery, Hamburg
'The 1988 Pictures'. Sonnabend Gallery, New York

1989
'The 1988 Pictures'. Christian Stein Gallery, London
'For Aids Exhibition'. Anthony d'Offay Gallery, London

1990
'Gilbert & George'. Hirschl and Adler Modern, New York
'25 Worlds by Gilbert & George'. Robert Miller Gallery, New York
'The Cosmological Pictures'. Sonnabend Gallery, New York
'Worlds & Windows'. Anthony d'Offay Gallery, London
'Eleven Worlds by Gilbert & George and Antique Clocks'. Desire Feurele Gallery, Cologne

1991
'20th Anniversary Exhibition'. Sonnabend Gallery, New York

1992
'New Democratic Pictures'. Anthony d'Offay Gallery, London

1994
'Gilbert & George'. Robert Miller Gallery, New York
'The Naked Shit Pictures'. Galerie Rafael Jablonka, Cologne

1995
'Gilbert & George'. Galerie Nikolas Sonne, Berlin

1997
'The Fundamental Pictures'. Sonnabend Gallery/Lehman Maupin, New York

1998
'Selected Works from The Fundamental Pictures'. Massimo Martino Fine Arts & Projects, Switzerland
'New Testamental Pictures'. Galerie Thaddaeus Ropac, Paris
'New Testamental Pictures'. Galerie Thaddaeus Ropac, Salzburg
'Black White and Red 1971 to 1980'. James Cohan Gallery, New York

2000
'The Rudimentary Pictures'. Gagosian Gallery, Los Angeles
'Zig-Zag Pictures'. Galerie Thaddaeus Ropac, Paris at FIAC

2001
'New Horny Pictures'. White Cube, London

2002
'Nine Dark Pictures'. Bernier/Eliades, Athens

Museum Exhibitions
1971
'The Paintings'. Whitechapel Art Gallery, London
'The Paintings'. Stedelijk Museum, Amsterdam
'The Paintings'. Kunstverein, Düsseldorf

1972
'The Paintings'. Koninklijk Museum voor Schone Kunsten, Antwerp

1973
'The Shrubberies & Singing Sculpture'. National Gallery of New South Wales, Sydney (a John Kaldor Project)
'The Shrubberies & Singing Sculpture'. National Gallery of Victoria, Melbourne (a John Kaldor Project)

1976
'The General Jungle'. Albright-Knox Gallery, Buffalo

1980
'Photo-Pieces 1971–1980'. Stedelijk van Abbesmuseum, Eindhoven

1981
'Photo-Pieces 1971–1980'. Kunsthalle, Düsseldorf
'Photo-Pieces 1971–1980'. Kunsthalle, Bern
'Photo-Pieces 1971–1980'. Georges Pompidou Centre, Paris
'Photo-Pieces 1971–1980'. Whitechapel Art Gallery, London

1984
'Gilbert & George'. Baltimore Museum of Art, Baltimore
'Gilbert & George'. Contemporary Arts Museum, Houston
'Gilbert & George'. Norton Gallery of Art, West Palm Beach, Florida

1985
'Gilbert & George'. Milwaukee Art Museum, Milwaukee
'Gilbert & George'. The Solomon R. Guggenheim Museum, New York

1986
'Pictures, 1982 to 85'. Capc, Bordeaux
'Charcoal on Paper Sculptures 1970 to 1974'. Capc, Bordeaux
'The Paintings 1971'. The Fruitmarket Gallery, Edinburgh
'Pictures, 1982 to 85'. Kunsthalle, Basel
'Pictures, 1982 to 85'. Palais des Beaux-Arts, Brussels

1987
'Pictures, 1982 to 85'. Palacio de Velasquez, Madrid
'Pictures, 1982 to 85'. Lenbachaus, Munich
'Pictures, 1982 to 85'. Hayward Gallery, London
'Pictures'. Aldrich Museum, Connecticut

1990
'Pictures, 1983–88'. Central House of The Artists, New Tretyakov Gallery, Moscow

1991
'The Cosmological Pictures'. Palac Sztuki, Krakow
'The Cosmological Pictures'. Palazzo delle Esposizioni, Rome

1992

'The Cosmological Pictures'. Kunsthalle, Zurich
'The Cosmological Pictures'. Wienere Secession, Vienna
'The Cosmological Pictures'. Ernst Múzeum, Budapest
'The Cosmological Pictures'. Gemeentemuseum,
The Hague
'New Democratic Pictures'. Aarhus Kunstmuseum, Aarhus
'The Cosmological Pictures'. Irish Museum of Modern
Art, Dublin
'The Cosmological Pictures'. Fundació Joan Miró, Barcelona

1993

'The Cosmological Pictures'. Tate Gallery, Liverpool
'The Cosmological Pictures'. Württembergischer
Kunstverein, Stuttgart

'Gilbert & George China Exhibition'. National Art
Gallery, Beijing
'Gilbert & George China Exhibition'. The Art Museum,
Shanghai

1994

'Gilbert & George'. Museo d'Arte Moderna della Città
di Lugano, Lugano
'Shitty Naked Human World'. Wolfsburg Kunstmuseum,
Wolfsburg

1995

'The Naked Shit Pictures'. South London Art Gallery,
London

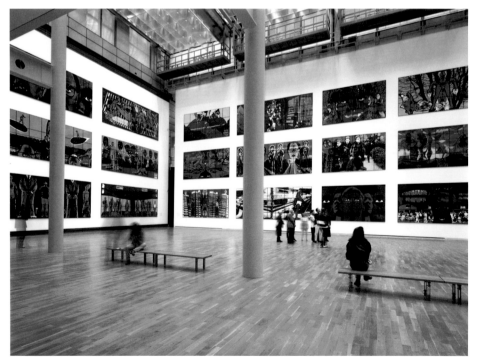

'Shitty Naked Human World', Wolfsburg Kunstmuseum, 1994

1996
'The Naked Shit Pictures'. Stedelijk Museum, Amsterdam
'Gilbert & George Retrospective'. Galleria d'Arte Moderna, Bologna

1997
'Gilbert & George Retrospective'. Sezon Museum, Tokyo
'Gilbert & George'. Magasin 3, Stockholm
'Gilbert & George Retrospective'. Musée d'Art Moderne de la Ville de Paris

1998
'New Testamental Pictures'. Museo di Capodimonte, Naples

1999
'Gilbert & George, 1970 – 1988'. Astrup Fearnley

Museet for Moderne Kunst, Oslo
'Gilbert & George, 1986 – 1997'. Drassanes, Valencia
'The Rudimentary Pictures'. Milton Keynes Gallery, Milton Keynes (inaugural exhibition)
'Gilbert & George, 1991 – 1997'. Ormeau Baths Gallery, Belfast

2001
'The Art of Gilbert & George'. School of Fine Art, Athens

2002
'Dirty Words Pictures'. Serpentine Gallery, London
'Gilbert & George: An Exhibition'. Kunsthaus, Bregenz
'The Art of Gilbert & George'. Belem Cultural Centre, Lisbon
'Nine Dark Pictures'. Portikus, Frankfurt

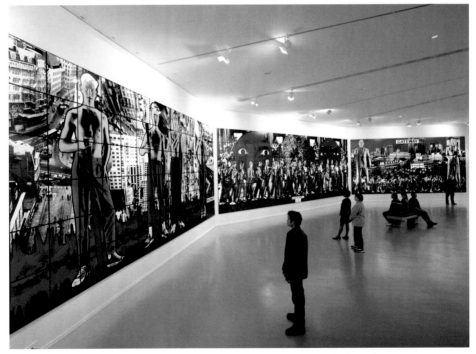

'Gilbert & George Retrospective', Musée d'Art Moderne de la Ville de Paris, 1997

Group Exhibitions (selected)

1969
'Conception'. Stadtisches Museum, Leverkusen

1970
'Conceptual Art, Arte Povera, Land Art'. Civic Gallery of Modern Art, Turin
'(Untitled)'. C.A.Y.C., Buenos Aires

1971
'Prospect 71 Projection'. Kunsthalle, Düsseldorf
'The British Avant-Garde'. Cultural Center, New York

1972
'Documenta 5'. Kassel
'The New Art'. Hayward Gallery, London
'Concept Kunst'. Kunstmuseum, Basel

1973
'Art as Photography'. Kunstverein, Hanover and touring
'From Henry Moore to Gilbert and George'. Palais des Beaux Arts, Brussels

1974
'Word Works'. Mt San Antonio College, California
'Medium Photography'. Kunstverein, Hamburg and touring
'Kunst Bleibt Kunst'. Kunsthalle, Cologne

1976
'Arte Inglese Oggi'. Palazzo Reale, Milan
'The Artist and the Photograph'. Israel Museum, Jerusalem

1977
'Europe and the 70s'. Art Institute of Chicago and touring

1978
'Documenta 6'. Kassel
'38th Venice Biennale'. Venice
'Works from The Crex Collection'. Louisiana Museum, Humelbaek and touring

1979
'On Walks and Travels'. Bonnefantenmuseum, Maastricht

'Un Certain Art Anglais'. Musée d'Art Moderne de la Ville de Paris
'Warhrenhmungen, Aufzeichnungen, Mitteilung'. Museum Haus Lange, Krefeld
'Hayward Annual'. Hayward Gallery, London

1980
'Kunst in Europe Na '68'. Museum voor Hedendaagse Kunst, Ghent

1981
'Explorations in the 70s'. Plan for Art, Pittsburgh
'Artist and Camera'. Arts Council of Great Britain, touring

1981
'16 Bienal de São Paolo'. São Paolo
'British Sculpture in the Twentieth Century'. Whitechapel Art Gallery, London
'Project 6: Art in the 80s'. Walker Art Gallery, Liverpool
'Aspects of British Art Today'. Metropolitan Art Museum, Tokyo
'Documenta 7'. Kassel

1983
'Photography in Contemporary Art'. National Museum of Modern Art, Tokyo
'New Art'. Tate Gallery, London
'Urban Pulsers: The Artist and the City'. Plan for Art, Pittsburgh

1984
'The Critical Eye'. Yale Center for British Art, New Haven
'Artistic Collaboration in the 20th Century'. Hirshhorn Museum and Sculpture Garden, Washinton D.C.
'5th Sydney Biennale: The British Show'. Art Gallery of Western Australia, Perth and touring
'Turner Prize Exhibition'. Tate Gallery, London
'Dialog'. The Moderna Museet, Stockholm

1985
'Overture'. Castello di Rivoli, Turin
'Paris Biennale'. Grande Halle, La Villette, Paris
'Carnegie International'. Carnegie Instiute, Pittsburgh

1986
'Mater Dulcissima'. Chiesa dei Cavalieri di Malta, Siracusa
'Forty Years of Modern Art'. Tate Gallery, London

1987
'British Art in the 20th Century'. Royal Academy of Arts, London

1988
'Red Yellow Blue – The Primary Colours in 20th Century Art'. Kunstmuseum, St Gallen

1989
'Bilderstreit'. Kolner Messe, Cologne

1990
'The Great British Art Show'. McLennan Galleries, Glasgow

1991
'Metropolis'. Martin Gropius Bau, Berlin

1992
'Pour la Suite du Monde'. Musée d'Art Contemporain, Montreal
'All Roads Lead to Rome'. Palazzo delle Esposizioni, Rome

1994
'Visions Urbaines'. Georges Pompidou Centre, Paris

1995
'Attitudes/Sculptures'. Capc, Bordeaux

1996
'La Vie Moderne en Europe 1870–1996'. Museum of Contemporary Art, Tokyo

1997
'Treasure Island'. Fundação Calouste Gulbenkian, Lisbon
'The 2nd Kwangju Biennale'. Kwangju

1998
'Art Treasures of England'. Royal Academy of Arts, London

Living Sculpture Presentations
1969
Our New Sculpture. St Martin's School of Art, London; Royal College of Art, London
Reading from a Stick. Geffrye Museum, London
Underneath the Arches. Slade School of Fine Art, London; Cable Street, London
Sculpture in the 60s. Royal College of Art (with Bruce McLean)
In the Underworld. St Martin's School of Art (with Bruce McLean)
Impresarios of the Art World. Hanover Grand Preview Theatre (with Bruce McLean)
Meeting Sculptures. Various Locations, London
The Meal Ripley. Bromley, Kent (with David Hockney)
Metalised Heads. Studio International office, London
Telling a Story. The Lyceum Ballroom, London
The Singing Sculpture. National Jazz and Blues Festival, London
A Living Sculpture. At the opening of 'When Attitudes Become Form', ICA, London
Posing the Stairs. Stedelijk Museum, Amsterdam

1970
3 Living Pieces. BBC Studios, Bristol
Lecture Sculpture. Museum of Modern Art, Oxford; Leeds Polytechnic, Leeds
Underneath the Arches. Kunsthalle, Düsseldorf; Kunstverein, Hanover; Block Gallery Forum Theatre, Berlin; Kunstverein, Recklinghausen; Heiner Friedrich Gallery, Munich; Kunstverein, Nuremberg; Wurttembergischer Kunstverein, Stuttgart; Museum of Modern Art, Turin; Sonja Henie Niels Onstad Foundation, Oslo; Stadsbiblioteket Lyngby, Copenhagen; Gegenverkehr, Aachen; Heiner Friedrich Gallery, Cologne; Kunstverein, Krefeld
Posing Piece. Art & Project, Amsterdam;
Standing Sculpture. Folker Skulima Gallery, Berlin

1971
Underneath the Arches. Garden Stores Louise, Brussels; For BBC play 'The Cowshed', London; Sonnabend Gallery, New York

1972

Underneath the Arches. Kunstmuseum, Lucerne; L'Attico Gallery, Rome

1973

Underneath the Arches. National Gallery of New South Wales, Sydney (a John Kaldor project); National Gallery of Victoria, Melbourne (a John Kaldor project)

1975

Shao Lin Martial Arts. Collegiate Theatre, London (film)
The Red Sculpture. Art Agency, Tokyo

1976

The Red Sculpture. Sonnabend Gallery, New York; Konrad Fischer Gallery, Düsseldorf; Lucio Amelio Gallery, Naples

1977

The Red Sculpture. Sperone Gallery, Rome; Robert Self Gallery, London; Sperone Fischere, Basel Art Fair; Mtl Gallery, Brussels; Museum Van Hedendaagse Kunst, Ghent; Stedelijk Museum, Amsterdam

1991

The Red Sculpture. Sonnabend Gallery, New York

Magazine Sculptures
1969

The Words of The Sculptors. Jam Magazine, pp. 43–7, Autumn

1970

The Shit and The Cunt. Studio International, pp. 218–21, May
With Us In Nature. Kunstmarkt, Cologne (catalogue)

1971

Two Text Pages Describing Our Position. The Sunday Times Magazine, 10 January

1972

There Were Two Young Men. Studio International, pp. 220–1, May

1973

Balls. Avalanche, pp. 26–33, Summer–Fall

Postal Sculptures
1969

The Easter Cards
Souvenir Hyde Park Walk
A Message from the Sculptors (dated 1970)
All My Life
1969/70 New Decadent Art

1970

The Sadness in Our Art

1971

The Limericks

1972

1st Post-Card
2nd Post-Card

1973

The Red Boxers

Works in Edition
1970

The Worlds of the Sculptors (edition 35)
Walking Viewing Relaxing (edition 13)
To Be With Art Is All We Ask (edition 9)
Two Text Pages Describing Our Position (edition 19)

1971

The Ten Speeches (edition 10)
The Eight Limericks (edition 25)

1972

Morning Light On Art For All (edition 12)
Great Expectations (edition 12)
As Used by The Sculptors (edition 30)

1973

Reclining Drunk (edition 200)

1976
The Red Sculpture (edition 100)

1979
First Blossom (edition 50)

1993
The Singing Sculpture 1969–91 (edition 20)

Films by Gilbert & George
1970
The Nature of Our Looking (edition 4)

1972
Gordon's Makes Us Drunk (edition 25)
In the Bush (edition 25)
Portrait of the Artists as Young Men (edition 25)

1981
The World of Gilbert & George. Produced by Philip Haas for The Arts Council of Great Britain (70 mins)

Films about Gilbert & George
1984
Gilbert & George. South of Watford, ITV (with Ben Elton)

1986
Rencontre à Londres. Vidéo Londres, Michel Burcel, France
Gilbert & George. La Estación De Perpiñan, TVE, Spain

1991
The Red Sculpture. Sonnabend/Castelli, New York
The Singing Sculpture by Gilbert & George. Produced and directed by Philip Haas for Sonnabend/Methodact

1992
Gilbert & George: Daytripping. Produced and directed by Ian Mcdonald for Anglia Television

1997
The South Bank Show with Gilbert & George. Produced and directed by Gerry Fox for London Weekend Television

Publications
1970
Art Notes and Thoughts. Gilbert & George
To Be With Art Is All We Ask (edition 300). Gilbert & George
A Guide to Singing Sculpture. Gilbert & George

1971
The Paintings. Kunstverein, Düsseldorf
Side by Side (edition 600). Gilbert & George
A Day in the Life of Gilbert & George (edition 1,000). Gilbert & George

1972
'Oh, The Grand Old Duke of York'. Kunstmuseum, Lucerne

1973
Catalogue for Gilbert & George Australian Visit. John Kaldor, Sydney

1976
Dark Shadow (edition 2,000). Nigel Greenwood, London

1977
Gilbert & George. Taxispalais, Innsbruck

1980
Gilbert & George 1968 to 1980. Introduction by Carter Ratcliffe. Van Abbesmuseum, Eindhoven

1984
Gilbert & George. Introduction by Brenda Richardson. Baltimore Museum of Art, Baltimore

1985
Death Hope Life Fear. Introduction by Rudi Fuchs. Castello di Rivoli, Turin

1986
The Charcoal on Paper Sculptures 1971–1974. Introduction by Demosthenes Davvatas. Capc, Bordeaux
The Paintings 1971. Introduction by Wolf Jahn. The Fruitmarket Gallery, Edinburgh
The Complete Pictures 1971–1985. Text by Carter Ratcliff. Thames & Hudson, London

1989

For Aids Exhibition. Introduction by Gilbert & George. Anthony d'Offay Gallery, London
The Art of Gilbert & George. By Wolf Jahn. Thames & Hudson, London

1990

The Moscow Catalogue. Texts in Russian by Sergei Klovkov and Brenda Richardson. Gilbert & George and Anthony d'Offay Gallery, London
25 Worlds and Windows. Text by Robert Rosenblum. Robert Miller Gallery, New York
Worlds and Windows. Text by Robert Rosenblum. Anthony d'Offay Gallery, London
Gilbert & George: Postcard Sculptures and Ephemera 1969–1981. Introduction by Carter Ratcliff. Hirschl and Adler, New York

1991

Monarchy As Democracy. By Wolf Jahn. Anthony d'Offay Gallery, London and Oktagon, Munich
With Gilbert & George in Moscow. By Daniel Farson. Bloomsbury, London
The Cosmological Pictures. Texts in English and Polish, Italian, German, Hungarian, Dutch, Spanish by Rudi Fuchs and Wojciech Markowski. Gemeentemuseum, The Hague

1992

New Democratic Pictures. Texts in English and Danish by Anders Kold, Lars Morrell and Andrew Wilson. Aarhus Kunstmuseum, Aarhus

1993

The Singing Sculpture. Texts by Carter Ratcliffe and Robert Rosenblum. Thames & Hudson, London and Anthony McCall Associates, New York
Gilbert & George China Exhibition. Texts by Wojciech Markowski, Norman Rosenthal and interview with Andrew Wilson. Gilbert & George and Anthony d'Offay Gallery, London

1994

Gilbert & George: Recent Works. Robert Miller Gallery, New York
The Naked Shit Pictures. Text by Wolf Jahn. Galerie Rafael Jablonka, Cologne
Shitty Naked Human World. Text by Gilbert & George. Wolfsburg Kunstmuseum, Wolfsburg

1995

The Naked Shit Pictures. South London Gallery and Anthony d'Offay Gallery, London

1996

The Naked Shit Pictures. Stedelijk Museum, Amsterdam
Gilbert & George. Text by Danilo Eccher. Edizioni Charta, Milan/Galleria d'Arte Moderna, Bologna
Lost Day. Oktagon Verlag, Cologne (flick book)
'Oh, The Grand Old Duke of York'. Oktagon Verlag, Cologne (flick book)

1997

The Fundamental Pictures. Text by Robert Rosenblum. Alexander Roussos, London
Gilbert and George – Art For All 1971–1996. Texts by Robert Rosenblum and Sunihiro Nonomura. Sezon Museum of Art, Tokyo
Gilbert & George – Konst. Magasin 3, Stockholm
Gilbert & George. Interview by Martin Gayford. Musée d'Art Moderne de la Ville de Paris
The Words of Gilbert & George. With Portraits of the Artists from 1968 to 1997. Thames & Hudson in association with Robert Violette Editions, London

1998

New Testamental Pictures. Texts by Achille Bonito Oliva, Mario Codognato and Angela Tecce. Museo di Capodimonte, Naples

1999

Gilbert & George: A Portrait. By Daniel Farson. Harper Collins, London
Gilbert & George 1986–1997. Interview by Wolf Jahn. Generalitat Valencia, Valencia